SELECTING AND USING
CLASSIC CAMERAS

A User's Guide to Evaluating
Features, Condition & Usability
of Classic Cameras

Michael Levy

AMHERST MEDIA, INC. ■ BUFFALO, NY

To Cynthia, who has cheerfully endured my hobbies, enthusiasms and digressions for the past thirty-six years.

Published by:
Amherst Media, Inc.
P.O. Box 586
Buffalo, N.Y. 14226
Fax: 716-874-4508
www.AmherstMedia.com

Publisher: Craig Alesse
Senior Editor/Production Manager: Michelle Perkins
Assistant Editor: Barbara A. Lynch-Johnt
Assistant Editor: Matthew A. Kreib
Scanning Technician: Deanna Draudt
Editorial Assistant: Donna Longenecker

ISBN: 1-58428-054-9
Library of Congress Card Catalog Number: 00-135905

Printed in Korea.
10 9 8 7 6 5 4 3 2 1

Table of Contents

1.
Introduction

*U*NLIKE THE AUTOMOBILE-COLLECTING GAME, where well-established definitions of terms like "antique," "vintage" and "classic" cars exist, it is difficult to definitively state in terms of age

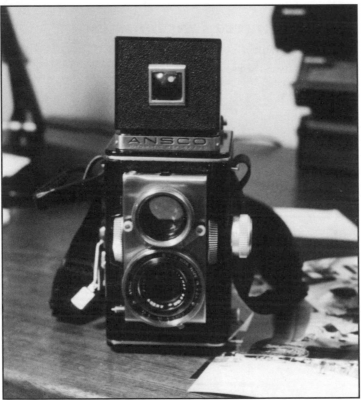

The Ansco Automatic Reflex of 1949 is a classic because of its vault-like construction and relative rarity.

alone what a classic camera is. For example, the most recently built Rolleiflex twin lens reflex works exactly the same way a sixty-five year-old Rollei "automat" does, and Leica's current M6 model is almost the same camera as the M3 of 1954—which, itself, was just an extension of the interchangeable-lens, thread-mount Leicas that revolutionized photography in the late 1920s.

This book is aimed at introducing the interested photographer to the charms and vagaries of classic

COAXING GOOD IMAGES OUT cameras with a view toward using them—rather than from a collector's

OF GRANDPA'S CAMERA WILL perspective. However, it will discuss a

MAKE YOU A BETTER, MORE little history, too; for without that, why would anyone be interested in such a

INVOLVED AND THOUGHTFUL photographic tool? This book will also

PHOTOGRAPHER. discuss the different types of old-timers, with some suggestions as to their selection, care and feeding won from hard-learned experience—a learning curve that continues to this day.

Most of all, I urge you to not simply acquire these instruments, but to use them, too. Coaxing good images out of Grandpa's camera will make you a better, more involved and thoughtful photographer. That's why college photography courses usually require the use of an all-manual camera.

2.
Why Use Classic Cameras?

*C*LASSIC CAMERAS CAN TEACH YOU a little photo history, and help you to become a better photographer (because you have to concentrate on each aspect of making an image). For the young (or the high-strung older person), they can also teach the virtues of patience and tolerance.

Using machinery that may be fifty years older than you requires patience: these are not point-and-shoot wonders of today. The instruments require attention, proper maintenance, good care and feeding. They can (and will) break or malfunction from time to time. But they can be a real bargain in terms of optical quality—even at "collector" prices—and they are loads of fun to use!

USING MACHINERY THAT MAY BE FIFTY YEARS OLDER THAN YOU REQUIRES PATIENCE: THESE ARE NOT POINT-AND-SHOOT WONDERS OF TODAY.

In some cases, finding a classic is delayed gratification. You might have lusted after a particular camera when you were in school and now you can buy it. For others, the satisfaction comes from coaxing a prize photo out of Grandpa's favorite camera. Classics break the ice when people see you using them. Sometimes using a relic like a folding "tourist" camera gets you inside the velvet ropes at an auto show or other special event. So rescue these cameras from the attic,

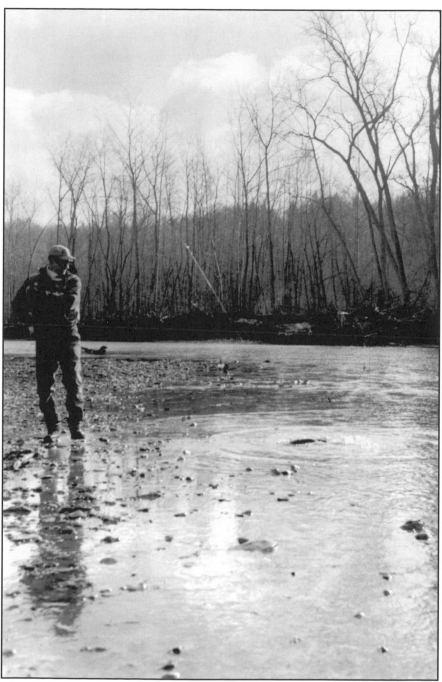

This winter steelhead fisherman was photographed with a Zeiss Ikoflex TLR that is twenty years older than he is!

feed in some film and see what happens to your photography. You might find, as I did, that classics are more fun than today's modern computerized wonders.

❦ WHAT EXACTLY *IS* A CLASSIC?

Most collectors agree that the classic period runs from about 1920 to 1965. Almost all agree that the cameras must be mechanical in operation (rather than computer-controlled, electronic, "automatic" cameras), although built-in electronic light meters seem to be acceptable.

> YOU MIGHT FIND, AS I DID, THAT CLASSICS ARE MORE FUN THAN TODAY'S MODERN COMPUTERIZED WONDERS.

Some stretch the definitions a bit at either end, even allowing the early auto-exposure cameras into the classic realm.

❦ WHAT IS A USABLE CLASSIC?

In my opinion, a *usable* classic camera is one that meets the criteria above, works, and uses readily available film. That means that my Kodak Monitor 616, although it meets the classic definition, is not a *usable* classic because 616 film is about 2½" wide (not 2¼", like the more familiar 120 film). If you can find any, you'll pay premium prices. Worse yet, age has rendered the camera's bellows sieve-like and has made most of the shutter speeds hang up. However, my fellow Amherst Media author Thomas Tomosy has cures for both those conditions, which can be found in his series of repair books (see page 179–180).

I suggest buying cameras that use 35mm cassettes, 120 roll film or 4" x 5" sheet film—those are the most common sizes with the most available emulsions.

Having said that, I must also admit to liking 127 film cameras (a film size that is tough to find at a decent price and usually only in a single black & white emulsion). I am also crazy about Minox cameras that use 9.5mm film, which is available worldwide—

although usually only by mail order, and rarely at a bargain price.

For some cameras, there are solutions. For example, the Monitor mentioned above was also made for 620 film. 620 film is exactly the same as the widely-available 120 film, but on a narrower spool with different slots for the advance mechanism.

YOU CAN RE-SPOOL 120 FILM ONTO 620 REELS IF YOU LIKE.

Kodak, which from the start realized film made more money than cameras, created this film size and built some great cameras for it. Given two spare spools and a changing bag or darkroom, you can re-spool 120 film onto 620 reels if you like.

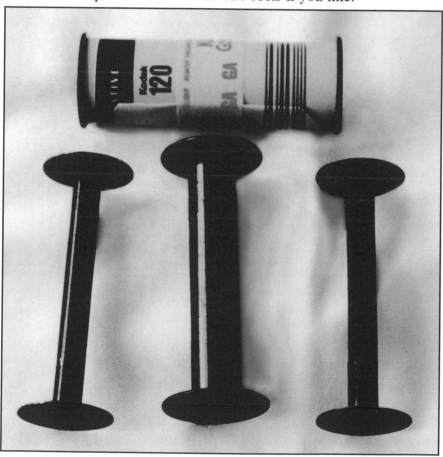

A 120 film spool flanked by two 620 film spools. 620 film is exactly the same as 120, but on a narrower spool with different slots for the advance mechanism.

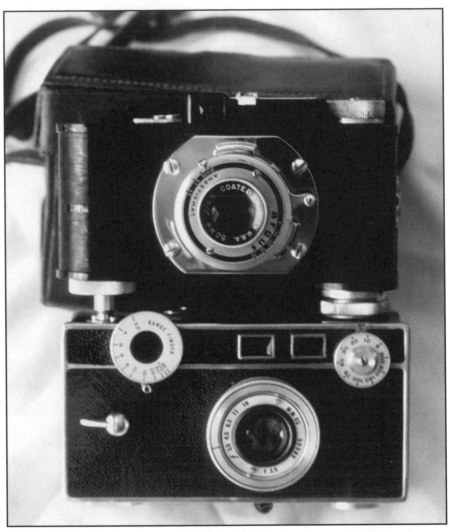

These usable classic cameras, the Argus A2B (top) and Argus C3 (bottom), were made in 1939 and still take great photos today.

For classic camera users, other "Kodak Moments" of the past can be equally frustrating. For example, around World War I the Rochester filmmaker built "vest pocket" cameras that took VP film, later called 127. It was a superb film size that gave negatives twice the size of a 35mm negative, and hence was much easier to use in a darkroom when printing enlargements. Yet the cameras are quite small, almost as tiny as today's smallest 35mm cameras. All over the world,

▣ Personal Experience

This book will tell you what I have learned about each camera type—and what I like and dislike. Everyone has different ideas, different experiences, as well as different skills. For example, if you can judge distance accurately, you may not want or need a rangefinder, which, in older cameras, can be subject to all sorts of (expensive!) problems. I suspect you probably have an inkling of what kind of camera most interests you, or you may have had experiences directly counter to mine. That's why the diversity of classic cameras is so interesting and that's what makes begging, borrowing and buying them so much fun. What is even more fun is learning how to use them effectively. Each section that deals with a particular type of camera will also offer some operational notes as well as the kind of photos for which each design seems best suited.

camera makers made "vest pocket cameras," and there were even some terrific tiny twin lens reflex cameras made by Rolleiflex and Yashica. I don't know if any color emulsions are available today in 127, but these cameras still fascinate me.

Other obsolete film formats include 828 (a 35mm film packaged as a roll film with paper backing), Bolta film that gives 1" x 1" negatives, and many more—including a huge number of wide roll films that produced postcard-sized images in the days when a contact print was about all an amateur could make. Even in recent times, we saw the disc (now long gone) and both 126 and 110 "Instamatic" cartridges. The former is dead and gone, but there are still some 110 films being packaged, which means that owners of those elaborate Rollei, Minolta and Pentax 110s can still use them today.

Large format users should also be cautioned: It is quite easy to obtain a decent press or view camera, but if you want to experiment with different film emulsions, stick to 4" x 5". The better format (in many minds) is 5" x 7", but that film is getting scarce. 8" x 10" is available in most black & white and color emulsions—but at a staggering cost per shot. Other sizes

◘ *Having Fun with Old Cameras*

I came of age during the days of the classic mechanical camera's rise to the forefront of photography, the era when *Life* and *Look* magazines were shaping the way we understood the world through photos and photo essays. For me, classic cameras are, in a small way, a return to youthful enthusiasms.

However, the recent boom in the classic camera market is not due to old fogies' nostalgia alone. People of all ages and skill levels are finding these to be wonderful precision instruments; cameras that still work as designed and built, dating back to the early days of the twentieth century.

(like 3¼" x 4¼") are obsolete—although some sheet film is available if you hunt around.

❦ PORTABILITY AND CONVENIENCE

Two themes stand out throughout the history of photography—portability and ease of use. The first Kodaks more than a century ago had both, being small boxes about 7" long that held enough roll film for one hundred 2½" circular exposures. When you reached the end, you sent the whole thing back to the Kodak lab in Rochester, NY. Shortly thereafter, your prints came back, along with a freshly-loaded camera. Today's one-time-use cameras are based on the same

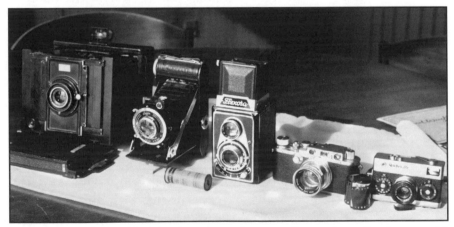

These cameras span the classic era—and get smaller and smaller from model to model. From the left: a 1920 Goerz Anschutz (12cm x 9cm sheet film); a 1930s Balda folder (120 roll film); a 1950 Flexora TLR; a 1935 Leica (35mm film), and a 1965 Rollei 35 (just big enough to hold 35mm film).

idea, just slightly updated. Of course, there are limits to what such tools can achieve. Serious photographers want the ability to focus, to adjust shutter speeds to capture movement, to adjust apertures for the amount of light available, or to select some combination of those controls for artistic purposes.

Portability. It was not long before the "hand and stand" roll film camera hit the market, and from about 1900 to about 1940 these were enormously popular. They folded to a compact size, were quite light, and relied on a leather or fabric bellows to extend the lens far enough to take anything from 2" square pictures to huge, postcard-sized images, depending on make and model. The cheaper ones, often called "tourist" cameras (because Kodak produced a long, long line of "Tourists"), were not much more flexible than a box camera. Some, such as the Voigtlander Bessa, Zeiss

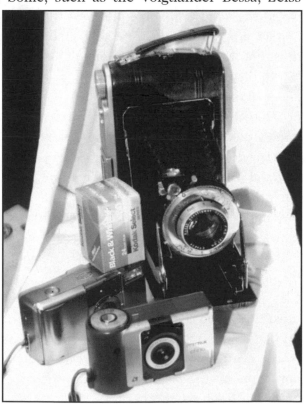

The amateur camera is portable—a folder for 120 film contrasted with a tiny 35mm point and shoot, and an even smaller APS system camera.

Ikonta and Super Ikonta (and others) had professional controls and lenses and produced excellent photos. They are still capable of doing so, although in use they may be a bit complicated, and prone to age failures that do not plague other styles of classics. Worse than that, most have "slow" lenses by today's standards. Except for the top models, they may have limited shutter speeds, too. Then, too, most were built down to meet a desired price point.

Shortly after photography took off as a hobby and became an adjunct to most middle-class family outings, two quite disparate kinds of cameras came along to revolutionize photojournalism: the Leica rangefinder camera and the Rolleiflex twin lens reflex (and their imitators). They were direct beneficiaries of the sharper film, better lenses and faster shutters that evolved between the two world wars and probably epitomize the classic era. Both were first visualized THERE ARE MANY, MANY WAYS TO ENJOY CLASSIC CAMERAS... during World War I and came out about a decade later. While they set the style for amateurs and professionals until the 1960s (when the single lens reflex 35mm became the norm), neither of these designs was a "first," and neither of them was necessarily a better camera design than the other. Several chapters are devoted to these types. However, there is no need to stick to those two brands.

This book should make it clear that there are many, many ways to enjoy classic cameras without looking for the cameras that are the most sought after by collectors (and hence most costly to acquire). Classic Leicas, for example, are too expensive for most of us, due to worldwide collector interest (more on that later), but their owners and users say they are worth every penny. Rolleiflex TLRs of any age still cost more on the used market than their clones from Yashica, Minolta and others.

Though I used a neat Leica for two wonderful years in high school and a wonderful Nikon rangefinder from 1965 to 1970, when I decided to return to "old-fashioned" rangefinder 35mm cameras I could afford neither make. Instead, I picked up a Contax "system," and for a time had an eclectic collection of Zeiss Ikon Contax bodies and lenses from the 1950s, and virtually brand-new (1980) Russian Kiev camera, which is actually the 1935 Contax design.

There is a kind of mongrel 35mm camera that, in my opinion, may be the best 35mm to get started with if your tastes are for a landmark, pocketable yet fully-capable picture-catcher—and you are on a budget. It is the folding 35mm rangefinder camera, typified by the Kodak Retina. If you want portability and don't need to change lenses, this may be the perfect introduction to classics.

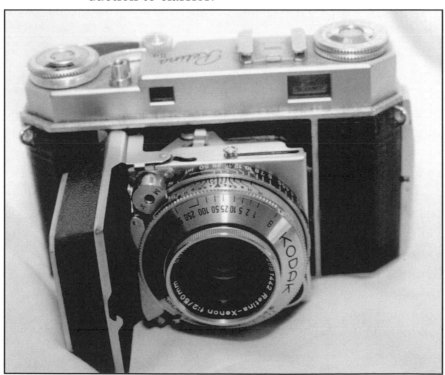

An earlier Retina, the landmark design introduced the now standard 35mm cassette.

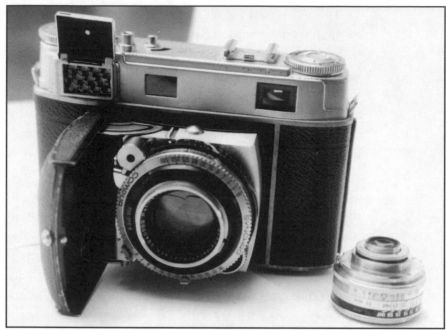

The Kodak Retina IIIc of 1954 has interchangeable front elements (here with a tiny 35mm front element next to camera) and a light meter. It's a folding, all-in-one "pocketable" camera.

Convenience. After World War II the single lens reflex became increasingly popular, not because of portability, but because of convenience. By that time, professionals and amateurs had come to enjoy lens interchangeability and wanted to use longer telephotos for distant objects, and macro lenses for extreme close-ups.

AFTER WORLD WAR II THE SINGLE LENS REFLEX BECAME INCREASINGLY POPULAR. . .

The SLR, both 35mm and the larger roll film models, offers through-the-lens viewing and can thus give accurate framing with lenses longer than 135mm, the limit for a rangefinder 35mm camera. With a variety of close-up accessories, the SLR user can look deep inside a flower with great accuracy—because one views the image through the picture-taking lens, not a separate viewing lens. I have used 35mm SLRs for over thirty years and for those two reasons would not be without at least one in my arsenal.

▣ *Feelin' Groovy*

There's something else about classic cameras that is totally subjective—"feel." This refers not only to the way these cameras handle and feel, but also to the images they produce. The classic lenses are often not as sharp as today's glass, but they often produce images that are more pleasing. Some find portraits done with lenses designed in the 1920s offer a kind of "plasticity," or "roundness" that is different from modern lenses, yet pleasing. It is hard to explain in words, but you may notice this in some of the photos in this book.

❦ SHEET FILM CAMERAS

Finally, there are the sheet film cameras, descendants of the nineteenth century studio and field cameras. While certainly *not* easily portable, they are "true" classics because they have not changed significantly in the last century (except for replacing wood bodies with metal or plastic, and bellows from cloth to neoprene). They have features no other instrument has.

The huge Graflex SLR could be your choice, but most would find its easier-to-use brother, the Graphic press camera, or a fully-adjustable view camera, an even more versatile tool. Since Timothy O'Sullivan's photographs of the wonders of Yellowstone helped make it into the world's first national park, careful workers including Ansel Adams and today's practitioners find these tools perfect for the patiently-awaited landscape, weather scene or architectural view. View cameras allow the greatest control of a negative prior to exposure of any camera type.

VIEW CAMERAS ALLOW THE GREATEST CONTROL OF A NEGATIVE PRIOR TO EXPOSURE. . .

❦ OTHER CLASSIC CAMERAS

This book will also mention other classic types, such as the viewfinder 35mm—the grandfather of today's ubiquitous point-and-shoot, fully automatic machine. These are typically Japanese, though there are some notable German machines, too, with leaf shutters and

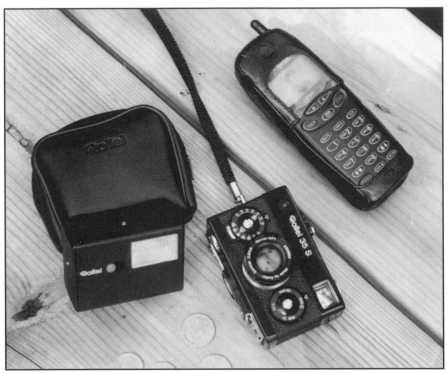

The tiny Rollei 35 of the 1960s was about as small as a 35mm camera can get and has an accurate CdS meter, too. The baby flash is good out to 30" and, like the camera, will fit in a shirt pocket.

permanently-mounted lenses. While none of them were aimed at pros (and hence may be a bit less sturdy), they can be a delightful and affordable entrée to classic cameras. Some of these use a bit of automation. They are certainly collectible because they were landmarks of miniaturization that probably ended the classic period by fulfilling the goal of portability that (with convenience) has marked the entire history of the camera.

❧ Is Modern Better?

There is something about today's lenses—computer-designed, made of optical glass loaded with trace elements of "rare earths" and multicoated to prevent flare—that pretty much makes all of them equal. For at least the last twenty years, *Consumer Reports* mag-

azine tests have noted almost identical lens performance at each price point. I've used both Nikon and Canon professional SLR systems and never noticed a significant difference in image quality, sharpness, contrast or flare—and I do a lot of flare-inducing backlit shooting.

I have noticed a difference in the way a particular camera design handles, though, and if I were stuck with just one camera and one lens I think it would be a 35mm rangefinder with a 35mm lens. It is fast, relatively quiet, and an extremely capable tool for the journalist in me. However, I could be just as content with a TLR Rolleiflex, which has some excellent qualities that the rangefinder camera does not have—including quieter operation and the fact that you look into the top of the camera, take aim at your intended subject and see the exact image you are capturing on the negative.

On the other hand, the classic SLR 35mm is great for extreme close-ups and extreme telephotos. It is *the* choice today for the outdoor or nature photographer and is the near-universal choice for almost every other professional. A classic SLR (if you get one that has not been trashed by hard professional use) can be had quite inexpensively, compared to its modern successor.

THE CLASSIC **SLR 35MM** IS GREAT FOR EXTREME CLOSE-UPS AND EXTREME TELEPHOTOS.

As part of the research for this book, I put together a virtually unblemished Nikkormat Ft2 (with an accurate through-the-lens meter), with a 50mm "normal" lens, a 35mm lens, a 55mm macro lens, a 105mm portrait lens and a 200mm telephoto lens, along with a "period" electronic flash for less than $400. That's the cost of the macro lens, alone, when it was new (and out of my price range) thirty years ago. For the same money, one could buy a new auto-focus, auto-exposure Canon EOS Rebel with a flash and a single 35mm–70mm

zoom lens. But trust me on this, the old Nikon lenses are all sharper, and the system offers great versatility—from a tiny flower, to people pictures, to sports telephotos—that can be achieved without a motor drive and in a camera that will *not* stop cold if you take it out snowshoeing or into a duck blind in January. This I know from experience—modern, automatic battery-driven cameras just don't cut it in the winter.

Other SLR systems are just as good as Nikon, and even better in terms of cost. The Minolta SR series or Pentax "Spotmatics" cost less than Nikon when new, and today still command lower prices than Nikons as used gear. Their lenses are just as sharp and come in almost as many focal length choices. Indeed, no less an authority than Ivor Matanle uses Minolta SLRs for professional work because, as an eyeglass wearer, he can see better through a Minolta eyepiece than any other.

OTHER SLR SYSTEMS ARE JUST AS GOOD AS NIKON, AND EVEN BETTER IN TERMS OF COST.

3.

Finding Your Classic

THE VERY BEST WAY TO OBTAIN a classic camera is for free. If you are one of those photographers who does not trade up but simply adds cameras, you may already have one or more classics gathering dust someplace. If your parents, grandparents or other relatives were photographers when you were growing up, they may have some cameras sitting around that

. . .YOU MAY ALREADY

HAVE ONE OR MORE

CLASSICS GATHERING

DUST SOMEPLACE.

you could borrow (or even be gifted with). My Uncle Fred, for example, has always liked "little" cameras and has a substantial collection of miniatures and subminiatures, ranging from the tiny Zeiss Kolibris of the 1920s (using 127

film), to the late '60s Mamiya 16s and Minox "spy" cameras, to a bunch of half-frame 35mm cameras that take seventy-two photos on a 36-exposure roll of 35mm film. Some are brilliant little designs, and some collectors—like Fred—specialize in these. He's promised to give me one when I visit him next.

❦ WHERE TO LOOK

If you decide to buy a classic, it pays to know what you are looking for (see page 179–180 for publications that can help), and to consider buying from your local camera shop.

A well-stocked camera shop that deals in used equipment can be a trove of classics.

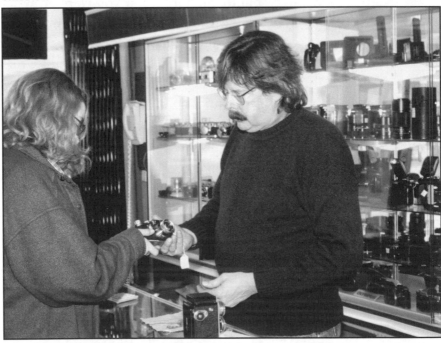

Buying your classic from your local dealer offers you the opportunity to examine and test the camera before you buy. Shown here, M&W in Buffalo, NY, is one such source for the author.

Estate Sales, Flea Markets and Antique Dealers.
Since the thrill of the hunt is also part of this hobby,
experience suggests you start going to garage sales, tag
sales or moving sales. It is here that you'll likely find
the best deals—and often even find "steals." Although
the chances these days of finding a bar-
gain basement Hasselblad are as slim as
finding a pristine Packard Super 8, you
can actually see what's offered, and the
prices here should be lower than any
other source. Estate sales can also be
good, although the ones that are run by
"sales consultants" tend to have optimistic pricing.

ESTATE SALES ALSO CAN BE
GOOD, ALTHOUGH THE ONES
THAT ARE RUN BY "SALES
CONSULTANTS" TEND TO
HAVE OPTIMISTIC PRICING.

*You can also discover great finds at a flea market stall. This one specializes in
old photos as well as highly collectable Leicas.*

When buying from a dealer, flea market or garage sale, take the time to test the equipment, check the type of battery it takes (if any) and note the film type required. The camera should also be comfortable for you to use.

Sometimes you have to line up and stand outside in the cold for an hour just to get in! Antique shops have high price expectations, too; but here, at least, you can always dicker.

Newspaper Ads. Flea markets, used camera dealers and camera swap meets are the best places to find accessories like lenses, shades or auxiliary viewfinders, in my experience. However, do pay attention to

newspaper ads. I recently bought an unused Yashica 635—complete with instruction manual, case and the adapter kit that allows use of 35mm film for $65—what it cost brand new in 1954!

On-Line Auctions. On-line auctions, like eBay at <www.eBay.com>, have had a dramatic effect on classic camera collectors. Some members of one on-line collector's group, the International Directory of Camera Collectors, dislike eBay because they believe it has not only inflated prices of cameras and accessories, but caused their favorite specialty camera dealers either to quit showing up at camera shows, or to simply show off stuff that they will later post on-line.

I happen to be an eBay fanatic, but long ago realized that it is silly to get into a bidding war. Here's a good example of what I mean. As of this writing, a prism viewfinder to fit atop a modern Rollei TLR will cost around $200–$400 at eBay auctions, and seems to be selling at camera stores in the $400 range. This device allows you to use your TLR at eye level, see the whole ground glass for focusing, and compose, without reversing the image, so that things move the right way. However, although the prisms are scarce and expensive, I bought a reasonably sound Rolleiflex *with* that prism and the regular waist-level finder for $400 from eBay. I made one bid that was high enough to hold and picked up $600 worth of gear for $200 less than current market value.

THIS DEVICE ALLOWS YOU TO USE YOUR TLR AT EYE LEVEL. . .

I have been stung on eBay, too. Unlike shopping at your local camera store, you cannot examine items before you buy them, and not all sellers will give you a full or even partial refund if the camera needs repair. The people who use eBay are self-policing (log on and look at the "feedback" area to get an idea of how this works), so there are limited ways to check on the

legitimacy of buyers/sellers. I have made deals with buyers and sellers from Australia, Russia, Lithuania, Slovakia, Spain, Scotland and Israel, as well as most of our fifty states. I got one camera that needed a shutter overhaul (and got $75 from the seller to help pay for that). I also got one camera whose shutter did not work and got my money back. I also had to hound one seller for months before he sent the camera I bought. I have refunded purchase prices twice, both times because the camera I sold had a fault I did not know about (I never tried that feature to see if it worked).

Local Camera Shops. Because of the potential for price inflation and other problems with purchasing on-line, buying at your local camera shop may be best. This is especially true if you are looking at big-ticket items such as Leicas or Rolleis. A really nice, late '60s Rollei with the same f2.8 Zeiss Planar lens as the newest model (and a coupled selenium exposure meter that still works accurately) can be bought on eBay for between $700 to $1,000 these days. A meterless Leica M2 or M3 with a decent lens might cost you twice that. However, I've seen terrific Rolleis in my local camera shops for around $600, and M-series Leicas that also sell for less than the maniacally inflated eBay price.

...BUYING AT YOUR LOCAL CAMERAS SHOP MAY BE BEST.

In addition, camera stores usually guarantee that these cameras work. They have often serviced the camera throughout its life. Also, camera shops usually offer return privileges if you are not satisfied. Moreover, the cameras normally look great because dealers tend to keep only the best (even they unload the scratch and dent "user" cameras on eBay!). Best of all, you can look at the items, hold them, see if you like the way they work and see if you can focus and operate them easily. Each of us has individual eye-

▣ Film Format

If you plan on *using* any medium format camera, make sure it takes 120 size film! A lot of wonderful Kodak (and other) cameras used 620 film—the same stock, the same paper backing, but on narrow spools no longer made. You can buy re-spooled 620 film (at high prices) or re-spool your own, if you like such projects.

sight, and problems tend to get exacerbated with the years. Some rangefinder cameras I used to enjoy in my salad days are almost unusable for me now that I wear bifocals. I need to wear my glasses to see clearly, and with the glasses on I can no longer see the frame lines in the viewfinder. While you can discover this at a camera store or a camera show, you can't learn that over the Internet!

Not every town has a camera store that features old-time gear, and even in big cities some dealers of classics have better reputations than others. In my town, three stores deal in classics, and I have been warned to avoid each of them. I ignored those warnings and bought used gear from each store, and I was satisfied each time. I've even scored some real bargains in viewfinders, lens caps and other easy-to-lose accessories for my clutch of classic clunkers.

I'VE EVEN SCORED SOME REAL BARGAINS IN VIEWFINDERS. . .

Mail Order. I have also bought cameras and accessories from mail order specialists in the field of collectibles and have usually gotten what was advertised at a fair price—normally with a five- or seven-day return privilege.

In the end, it comes down to the old adage: *you pays your money, and you takes your chances.*

❦ WHAT'S OUT THERE

Viewfinders. Bargains are still to be had in many Japanese and German 35mm cameras—Agfa, low-end

Voigtlander, Diax, Olympus, Petri and Yashica and Ricoh, and even the humble and ubiquitous American-made Argus 35s and Bolseys. These may not be as glamorous as Contax, Canon or even Kodak Retina, but they can still be quite good. Those I've owned had noninterchangeable lenses of 35mm to 50mm, usually with an f2.8 maximum aperture, and leaf shutters that might only go up to $1/300$ of a second. They provide the least expensive way to get started in classic photography. They have the advantage of being viewfinder cameras that allow you to watch the scene evolve and snap it at the "decisive moment" with no blackout at the instant of exposure. They are also quiet and unobtrusive.

Small Cameras. Some superb small cameras were made for 127 film, but I'd avoid them as users. Only one or two black & white 127 film emulsions are still made today (one in Croatia), and they cost $5–$11 a roll at that. 828 was another great "Kodak Moment," that, like the disc camera and the 126 Instamatic cartridge, is today as dead as the dodo. Kodak and Fuji still make a limited number of color emulsions in 110 film cartridge format and some wonderfully inventive cameras were made for all of these defunct formats, which also include 616, 130, etc. All might be worthwhile for collecting purposes, but not as potential users if film cost/availability is going to be an issue.

SOME SUPERB SMALL CAMERAS WERE MADE FOR 127 FILM, BUT I'D AVOID THEM AS USERS.

Folding Cameras. Folding roll film cameras, especially those with scale focusing rather than coupled rangefinders, can be super deals. Cameras with coupled rangefinders cost more than scale-focus cameras, but either type can be found for $30–$50 at camera shows or flea markets (or the back shelf of a camera store that carries used equipment). Some of them can be amazingly good picture-takers. Look for one with a

Zeiss Ikonta C, 6" x 9"
format with five-speed
shutter. (Photo courtesy
of Peter B. Williams.)

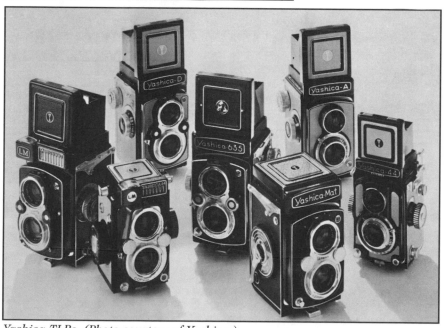

Yashica TLRs. (Photo courtesy of Yashica.)

light-tight bellows, sturdy support struts, a good three- or four-element lens and shutter speeds at least to a $1/200$ of a second. Zeiss Super Ikontas are the prizes here, and are subsequently collector-priced when compared to their less esteemed Ikonta and Nettar brethren. The Mamiya 6, a 2¼" square folder, is also pricey, since collectors drive that market as well. However, there are hordes of more economical Ensigns and Agfas out there, too.

Twin Lens Reflex. Twin lens reflexes seem a better choice than folders, if you like 2¼" x 2¼" negatives. They are easier to use, and are less likely to leak light. Good used Rolleiflexes can be found for around $600, good late-model Rolleicords for half that, and Minolta Autocords and Yashicamats should sell for substantially less. Roll film SLRs, such as Hasselblads, are usually much more expensive.

THEY ARE EASIER TO USE, AND ARE LESS LIKELY TO LEAK LIGHT.

4.
Where to Learn About Classics

*I*HAVE MADE THE CASE for buying from the local camera store that sells used equipment because they offer you the chance to look at, and perhaps even try out, a camera or lens before committing to purchasing it. Some mail-order classic dealers may do the same. Learning about a camera before you buy is an important part of the process, and will help ensure you enjoy using your equipment.

❦ CLASSIC CAMERAS ON THE INTERNET

The Internet is a great place to look at and learn about cameras. Using any search engine, you can pick "photography" or "classic camera" and you find everything from <graflex.org> (for large format users and fans of that press camera), to <photoshopper.com/edit> (articles on camera collecting), to classified ads and groups like the Internet Directory of Camera Collectors (IDCC), whose members share care and maintenance notes as well as gripe about prices. For no charge, you can join the IDCC to receive scads of e-mail (some of it pretty opinionated) from all over the world. The group is extremely helpful, providing answers to niggling questions such as what filters might fit an old Mamiyaflex.

THE INTERNET IS A GREAT PLACE TO LOOK AND LEARN ABOUT CAMERAS. . .

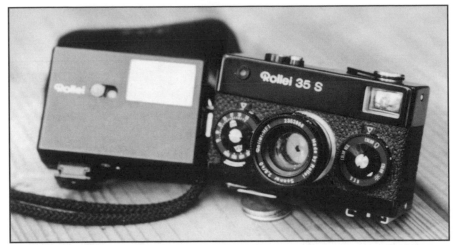

The Rollei 35, not much taller than a 35mm cassette, was an instant "cult" camera, and is still favored by many photographers today for it superb lens.

Be sure to check out their twice-monthly swap meet; you can find some real bargains here.

A must for medium format fanatics is <www.smu.edu/~monagha/mf/index> which has, among other things, an excellent primer on how to get into medium format at a reasonable cost. Use a good search engine, like Dogpile or Google, and you will find many, many more links for enthusiast groups.

Whether you shop on eBay or not, the photos that accompany the descriptions are a wonderful way to become familiar with a wide variety of cameras. <Amazon.com> also has a camera auction site, and several of the "portals" such as AOL or Yahoo! have classifieds and/or online auctions, too. But at this writing, eBay is the leader.

. . . THE PHOTOS THAT ACCOMPANY THE DESCRIPTIONS ARE A WONDERFUL WAY TO BECOME FAMILIAR WITH A WIDE VARIETY OF CAMERAS.

❦ CLASSIC CAMERAS IN BOOKS

The definitive print reference to classic cameras is *McKeown's Price Guide to Antique and Collectible Cameras*. The latest biennial edition is in bookstores for around $125. It has around 6,000 photographs and

more than 25,000 cameras listed, in some cases with thumbnail histories of the manufacturers.

McBroom's Camera Bluebook, published by Amherst Media, is an excellent guide to used gear and has useful information about Leica M-series cameras and lenses, as well as other cameras that appeared in the later days of the classic era. The latest sixth edition includes hundreds of photos along with detailed model descriptions and pricing. It is in bookstores for $29.95.

Ivor Matanle's books *Collecting and Using Classic Cameras* and *Collecting and Using Classic SLRs* offer a fine overview of the best, most usable "classics" to seek. (*Collecting and Using Classic SLRs* is currently available only on the used book market.)

WHATEVER YOUR LEANINGS IN TERMS OF CAMERA TYPE OR BRAND, IT ALSO PAYS TO READ REFERENCE BOOKS THAT FOCUS ON SPECIFIC MAKES.

Whatever your leanings in terms of camera type or brand, it also pays to read reference books that focus on specific makes. Such books, while often pedestrian, have the necessary data to steer you clear of models to avoid. For instance, the "Mark II" Brandex may have had a design fault cured only by the "Mark IV," but not the "Mark III." It helps to know that before you commit.

5.
What to Look for When Buying

*M*Y FIRST PIECE OF ADVICE is to try for the best looking, best operating "name brand" equipment you can find. Then do as much testing as you can. Here's what I do:

❧ FOCUS

Start with focus, which is easy to check on a rangefinder, TLR or SLR camera. The focus ring, lever or wheel should operate smoothly. Binding (especially in a twin lens reflex) could be a sign the machine has been dropped. Start by focusing on a distant telephone pole or water tower at infinity and work down to where you can estimate the close-focus capabilities. As you focus, look to see that the distance scale on the lens is actually showing the same distance as your viewfinder or ground glass seems to. (I have encountered lenses that were reassembled incorrectly, so even this test can prove faulty when film is exposed.)

BINDING (ESPECIALLY IN A TWIN LENS REFLEX) COULD BE A SIGN THE MACHINE HAS BEEN DROPPED.

❧ SHUTTERS

Open the camera back and open the lens aperture to its fullest, then click away while looking through the back of the camera (this does not work with Leicas

A prospective buyer tests the shutter by firing it at all speeds. This gives a good idea of how well the shutter functions.

and some Leica copies, which load through the bottom). Try shutters at all speeds, several times each, starting with high speeds and working down. Then repeat the cycle. Sometimes shutter speeds work repeatedly, and sometimes they hang up—especially at the slow speeds. Most older cameras may be fine, or nearly so, at high speeds, but the slow speeds may drag.

A FOCAL-PLANE SHUTTER SHOULD LEAVE YOU WITH A BRIEF IMPRESSION OF THE RECTANGULAR OR SQUARE OPENING. . .

A focal-plane shutter should leave you with a brief impression of the rectangular or square opening, even at the highest speeds. Make sure the curtains don't "taper." Focal-plane shutters open one curtain and move it across the film plane, fol-

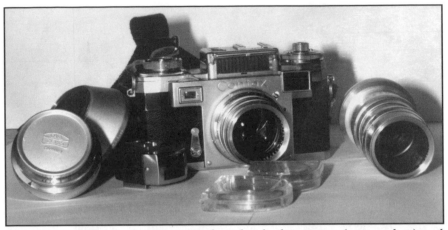

The Contax IIIa, Leica's serious rival, with a built-in meter (on top plate) and three superb lenses: f1.5 50mm Sonnar, 135mm Tessar telephoto on right, and the spectacular 21mm Biogon ultrawide on the left.

lowed by a second curtain to close off the slit of light. Even at its highest speed setting, a focal-plane shutter should leave you with the impression of a rectangular flash of light. If the retained image is anything less than the full rectangle, or is blurred or fuzzy on the side toward which the shutter travels, the shutter is "tapering." That is, the second blind travels slightly more quickly than the first and closes the slit before the first blind reaches the end of its trip. Tapering indicates that a repair job is needed, so figure that into the total cost.

Internal leaf shutters seem to be easier to "guesstimate." The speeds may be off somewhat, but they should all be apparently proportional (that is, the $1/5$ of a second shutter speed should appear to be open twice as long as the $1/10$ of a second shutter speed, and so on). Sometimes leaf shutters can be brought back to life simply by firing them repeatedly, which loosens up age-hardened lubricant. In leaf shutters, pay attention to whether or not the shutter opens and closes completely when fired, and does not leave a "pinhole" when it is supposed to be closed.

Do not attempt to use the self-timer! Cameras that otherwise work perfectly well at all shutter speeds often seem to get jammed when self-timers are used. If the camera is a "deal," and worth the $75 to $150 you might need to sink into a shutter cleaning and adjustment, you can do whatever you like. All I know is that every time I decide to try the self-timer on a classic the shutter jams—so I quit trying them.

Bellows, like on this Ansco Titan, must be checked carefully for light leaks. (Photo courtesy of Peter B. Williams.)

❦ BELLOWS

With folders and view cameras, the bellows must be considered suspect. The easiest way to check for light leaks is to open the camera back in a dark room and shine a flashlight into the bellows through the camera body. If you see pinholes, the film will see pinholes. This may be impossible to do at a yard sale, but you *can* do the reverse—open the camera bellows and back, hold the camera back to your eyes and cover it with a cloth or your coat. Look for light leaks coming in. You should certainly see any major problems.

The Goerz Anschutz (top) shows its eighty-two years of age in its frayed bellows.
The British Agifold of the 1950s has pristine bellows, even though the leatherette
is starting to peel from the rangefinder housing.

6.

Folding Cameras

*B*ELLOWS-EQUIPPED FOLDING ROLL FILM cameras are, next to view cameras, the "oldest" classic design. They often are touted as a "cheap" way to get into larger formats to produce sizable color transparencies. That can be true, pricewise, but after flirting with these things for three years, I'm not so sure they are a good deal in the long run—especially if you have to spend a fair amount of money to get one.

☙ THE TRUTH ABOUT FOLDERS

The first problem with folders is that you are asking the mechanism to do two disparate things—fold for compactness and portability, yet remain rigid when unfolded. The conflict between these attributes shows up quickly on the less well-engineered models. Furthermore, price (whether the camera is new or used) is not always a good indicator of engineering for rigidity. Worse yet, some of the best-engineered folders (most Kodak Tourists, Autographics and Vest Pockets fall into that category) use obsolete film sizes. I'd love to be able to take 3" x 5" negatives and contact print them as postcards, but who makes film stock 3" wide

THE CONFLICT BETWEEN THESE ATTRIBUTES SHOWS UP QUICKLY ON THE LESS WELL-ENGINEERED MODELS.

◼ *Folding Camera Components*

The folding camera is basically formed of four parts:

1. A box to hold a roll of film.

2. A drop-down/fold-out front with guide rails for the front standard.

3. A bellows that pulls out as the lens is extended and folds up as the lens is stowed.

4. A front standard that holds the lens and its shutter parallel to the film plane.

This allows for a fairly long focal length lens, say 105mm, to be used on a body that is compact enough to slip into a big jacket pocket. In general, these cameras are quite light for their operational bulk. Most have "by guess" focusing via a moveable front element, and most have limited shutter speeds.

anymore? If you want to use a camera, stay away from obsolete film sizes. Any roll film wider than 70mm (or 2½") cannot even be custom-packed these days.

For good results with a folder, the lens supports must remain in perfect plane with the film in the rear of the camera body. Superb materials, design and workmanship are required for two reasons. First, the struts that hold the bellows out must be mechanically perfect, and second, the (sometimes) convoluted linkages from the shutter release to the lens must also be sturdy. Yet almost all of these cameras were built down to a price. That means that the mechanics might be failure-prone—especially if the camera is sixty years old!

FOR GOOD RESULTS WITH A FOLDER, THE LENS SUPPORTS MUST REMAIN IN PERFECT PLANE WITH THE FILM IN THE REAR OF THE CAMERA BODY.

Still, they are worth experimenting with. I wanted larger negatives (6cm x 9cm, or 2¼" x 3½"—a common size on 120 roll film) and was curious about how these antique designs worked, so I purchased several and have used them all (except for the Kodak Monitor whose bellows leaked like a sieve).

With their "soft" lenses and less-than-accurate viewfinders, these cameras are nice for the "Pictorialist" effects favored by the "artistic" photographers of

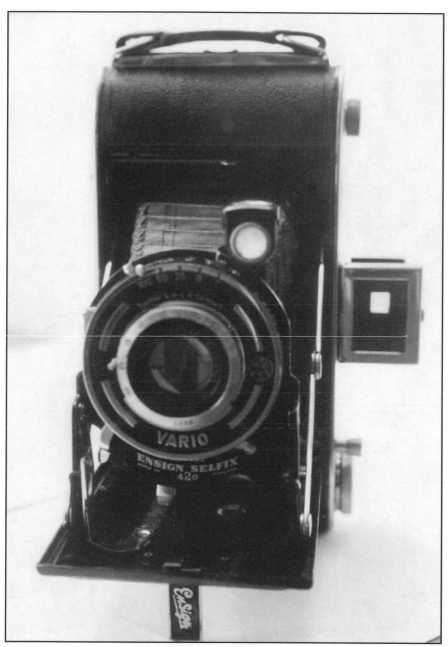

The British Ensign Selfix gives large negatives, has a three-speed shutter and a lens that ranges from f6.3 wide open to f22 stopped down.

(Left) An Ensign Selfix was used to take this "Pictorialist" view.

(Below) A picture taken with an Ensign Selfix as a test to see how sharp the old lens could be.

The Voigtlander Bessa remains a popular classic, as it takes readily available 120 film and delivers a 2¹/₄" x 3¹/₄" negative.

the World War I era. They took romantic views of their wives and daughters in frilly dresses and sought scenes like ivy-covered walls and mossy bridges. For such work, I rather liked the Ensign Selfix 420 and the Voigtlander Bessa. Both of these take 6cm x 9cm images, both have 105mm lenses of f6.3 and f4.5, respectively and limited shutter speeds. They also feature frame viewfinders that you look through when handholding, and a little reflex finder you can use (barely) to compose when the camera is standing on a wall, table or mounted on a tripod.

I think the Ensign is a bit sturdier than the Bessa, which has a faster shutter and a "better" lens. Both take 120 film and produce somewhat "soft" images. Print those negatives dark and moody, and you'll get almost exactly what

THEY ALSO FEATURE FRAME VIEWFINDERS THAT YOU LOOK THROUGH WHEN HANDHOLDING, AND A LITTLE REFLEX FINDER. . .

the Pictorialist school of the early 1900s seemed to be after. You can, of course, obtain the same murky and "artistic" results with any camera using a few tricks. However, I like to use a camera for what it seems best designed to photograph, and this camera seems perfect for "views," in either the country or city.

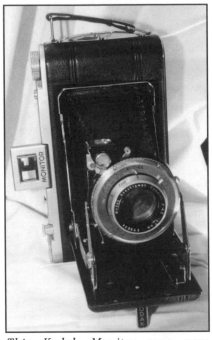

The Kodak Monitor is beautiful and quite advanced for this type of photography, with double-exposure prevention, an exposure counter (no need to look inside the little red window that can fog modern high speed films) and a good-to-excellent lens. Like most Kodaks, it is a sturdy mech-

This Kodak Monitor was very advanced for its day, but takes obsolete 616 film.

anism, as well. However, if you want to play with one of these, look for one that takes 620 film (which can be re-spooled using readily-available 120 rolls). Only after I got mine home did I realize that the 616 film size was obsolete and that the bellows were full of pinholes, too! This made for an intriguing project using Thomas Tomosy's repair manuals (see page 179–180). I never found all the leaks, but I consider this sort of puttering a good evening of entertainment that costs less than going to the movies. I subsequently sold the Monitor for a display piece and was recently given a neat 1939 Kodak 620 Junior that occupies my spare evenings.

ONLY AFTER I GOT MINE HOME DID I REALIZE THAT THE 616 FILM SIZE WAS OBSOLETE. . .

❦ SOME USEFUL TIPS
Most folders have quite "slow" lenses by today's standards, and even the very best may have limited shut-

This pristine Kodak "tourist" camera came from a church rummage sale. Folded, it slips into a coat pocket or can be carried along in a rucksack.

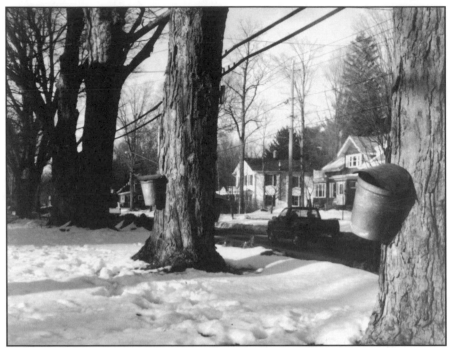

Maple Sugaring (Taken with a Zeiss Ikonta folder, using a Novar f3.5 lens).

ter speeds (up to around $^1/_{250}$ of a second). The matter of solidity, however, is the most important issue affecting any folders, which must both fold easily *and* remain rigid when unfolded. If you do happen to find one with adequately designed supports and good workmanship, there remains the problem of the shutter release. If it is on the camera body, the linkages from the shutter button to the lens must also be carefully constructed to literally go around corners. However, since most of these were "amateur" cameras, the quality of engineering often leaves much to be desired.

SINCE MOST OF THESE WERE "AMATEUR" CAMERAS, THE QUALITY OF ENGINEERING OFTEN LEAVES MUCH TO BE DESIRED.

I've found that a cable shutter release is a very handy accessory with folders. If you are handholding one of these beasts, you cannot reach around to trip the shutter without causing a fairly unsteady hold and

maybe blurring the photo—especially if you are shooting wide-open at $1/25$ of a second!

Still, of all the "classics," these cameras are the least costly to purchase—with two exceptions. The first is the Super Ikonta, which has an excellent built-in coupled rangefinder, modern "fast" lens and shutter up to $1/500$ of a second. The second is the Mamiya 6 from the 1950s, which has the same features. The Mamiya has another intriguing wrinkle: the back (rather than the lens) moves to focus. These two cameras are my first choice for "serious" (or at least flexible) photography with a folder, but both of are very pricey due to the interest of collectors.

STILL, OF ALL THE "CLASSICS," THESE CAMERAS ARE THE LEAST COSTLY TO PURCHASE—WITH TWO EXCEPTIONS.

The Zeiss Ikon Ikonta is both my favorite folder and the one that has proven to be the best deal. First, it can be obtained in good-to-excellent condition for around $100 with the "lesser" Novar lens (a few were made with upscale Tessar optics). Ikontas have no rangefinder, just a scale focus on the lens. They take 120 film and give either twelve exposures at 6cm x 6cm, eight exposures at 6cm x 9cm, or sixteen shots at 6cm x 4.5cm. That is still three times the size of a 35mm negative, and thus much easier to print from if you do your own black & white enlarging. Moreover, the often denigrated Novar is a very sharp lens if stopped down a bit from its maximum aperture and it makes negatives with real "bite."

If you are serious about these folding cameras, try to pick up an accessory rangefinder, too. They are invaluable for closer distances, especially if you want to try available light photography with these cameras.

🌸 PROBLEM AREAS

As mentioned, the bellows are the most likely source of problems with folders. Bellows can be replaced

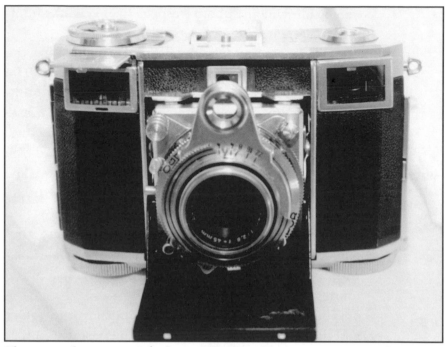

The external prism rangefinder on some Zeiss Ikon cameras is both fast and accurate.

(although at great expense) by several custom shops, and there are a dozen ways to patch them or even make new ones from scratch (see Thomas Tomosy's repair manuals on page 179–180). Shutters on these cameras are usually not tricky to repair and usually suffer no problems more significant than sticking or dragging. Perform the usual pre-purchase tests, and you'll see if the shutter needs work. The struts, lazy-tongs or other structures that hold the lens board in plane with the back must be solid and as true as the lens standard. Sometimes they are a little loose and out of true, but in my experience a camera that looks clean and well-cared for probably won't have severe problems along those lines.

THE STRUTS, LAZY-TONGS OR OTHER STRUCTURES THAT HOLD THE LENS BOARD IN PLANE WITH THE BACK MUST BE SOLID. . .

The most serious fault I have encountered on "good" folders is the body-mounted shutter release.

This piece is typically a Rube Goldberg affair of plungers, tongues, linkages and long rods that start at

THIS PIECE IS TYPICALLY A RUBE GOLDBERG AFFAIR OF PLUNGERS, TONGUES, LINKAGES AND LONG RODS.

the body of the camera to carry finger pressure to the front, where a final pivoting piece presses the release on the lens-mounted shutter. Rather than trying to fix these, which entails a fair bit of disassembling, I either use the manual release on the front of the camera (which can induce a little shake) or use a short cable release, which, on these machines, actually looks more traditional anyway!

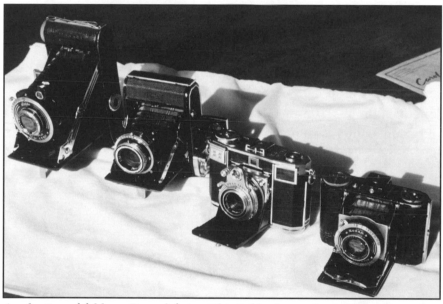

A selection of folders. From left to right: Balda 6cm x 9cm, Zeiss Ikonta that takes 6cm x 4.5cm images on 120 film, Zeiss Ikon Contessa (a 35mm folder), and a Nagel/Kodak Vollenda that uses 127 film, creating images twice as large as 35mm negatives.

7.

Retina: Pictures in Your Pocket

*I*HAVE A SOFT SPOT IN MY HEART for Kodak Retinas because a IIIc model obtained in a swap started me along this classic camera road. Ironically, this began after I purchased a new, fully-automatic Canon EOS outfit and lenses covering focal lengths 20mm–210mm. My wife suggested clearing out some cameras to make room (and partially to pay

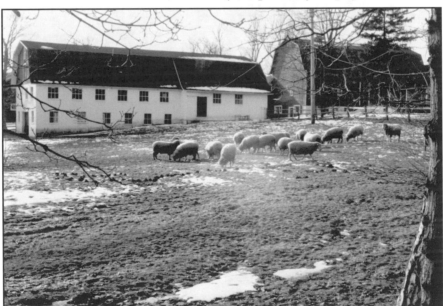

Sheep before lambing: Kodak Retina IIIc f8 at ¹⁄₆₀ of a second. Taken on Kodak TCN, a black & white film that, in this case, was developed and printed at the drugstore one-hour lab!

for the investment in modernity). So I posted my twenty-five year-old Nikon system and a bunch if other odds and ends on an Internet photography forum, sold most of them and swapped a Century 5" x 7" field camera for the Retina. After all, it took 35mm film (of which I had a plenitude) while the Century 5" x 7" cost at least $1 per exposure to shoot.

The Retina was a brilliant, landmark design that folded up like one of the larger roll-film cameras but fit into a jacket pocket. Its small size minimized the problems of larger folders (detailed in the previous chapter) and its accurate—if age-dimmed— rangefinder reminded me how much I always liked 35mm rangefinder cameras. I found myself shooting as often with the Retina as I did with the lighter but far bulkier and more obtrusive Canon SLR—despite its full automation, superb metering capabilities and motordrive. The more I slowed down, the better my pictures seemed to be, and using a handheld meter to gauge exposures was not a problem.

THE RETINA WAS A LANDMARK DESIGN THAT FOLDED UP LIKE ONE OF THE LARGER ROLL-FILM CAMERAS BUT FIT INTO A JACKET POCKET.

Kodak Retina rangefinders remain a good choice for a beginner in classics. They have landmark status because the Retina was the first camera (in 1935) to introduce Kodak's daylight-loading cassette. Before that, every 35mm camera had its own proprietary, do-it-yourself bulk film to cassette scheme. All Retinas were made at the Nagel Werke, a German company owned by Kodak. Retinas are easy to load, and were (and remain) inexpensive compared to contemporary Leica or Contax cameras. They also feature Schneider or Rodenstock lenses in Compur shutters that some feel are the equal of contemporary Leitz or Zeiss optics. Their solid, inexpensive quality grabbed a huge market share, which they held into the late 1950s. They remain a near bargain on today's market.

The Retina IIa had no meter but it took either a 35mm or 80mm front element. The "bellows" in these were actually metal, not leather, so they seldom leak light.

Folded, Retinas can be carried in a jacket pocket. That means marred lenses are seldom an issue. Moreover, they were made in the millions, and most were "family cameras" (as opposed to professional beaters), so a lot of them are still in fine condition. An additional benefit is the number that were produced. According to the late George Mrus, one of the best Retina specialist repairers, "Enough junkers are out there for years of spare parts."

AN ADDITIONAL BENEFIT IS THE NUMBER THAT WERE PRODUCED.

🍃 HISTORY

The 1935 Retina had a scale focus lens and a simple viewfinder; in 1936, the Retina II offered a coupled

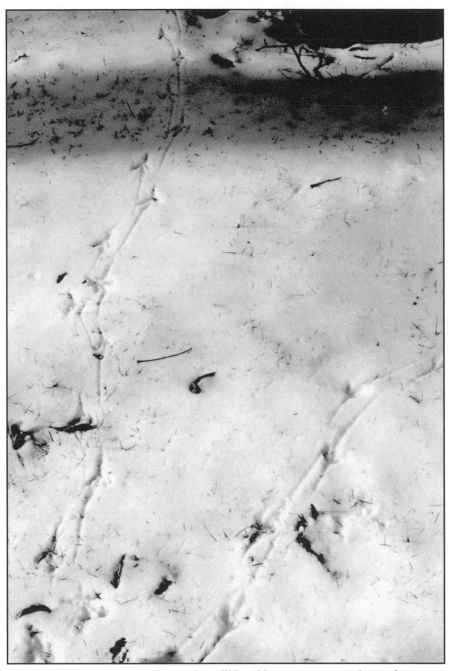

Carry a Retina in your pocket and you'll be able to capture anything of interest, such as turkey tracks found on a suburban lawn.

A pair of North Dakota scenes taken with the author's favorite Retina. The Kodaks offered great optics for the money.

rangefinder. Before its era ended in the 1960s, more than thirty types of Retina were made—including non-folders and Retina single lens reflexes.

The most useful of the folding Retinas are the post-World War II models. The IIa, which could be had with f2 and f2.8 Schneider Xenon or Rodenstock Heliogon lenses is diminutive and has a very good rangefinder, although many eyeglass wearers cannot see to the edge of the viewfinder. This camera has a more or less "conventional" lever wind that cocks the shutter for the next exposure. One can also slip an auxiliary viewfinder into the accessory shoe to frame the shot after focusing with the rangefinder.

The later "C" series (there were two series—small "c" and big "C") moved the rewind lever to the bottom of the camera. This is not as awkward as it sounds. C-series Retinas have a bright-line frame inside the viewer (which this eyeglass wearer finds preferable), and their "bellows" were metal, so the light leaks common with leather bellows should never be a problem.

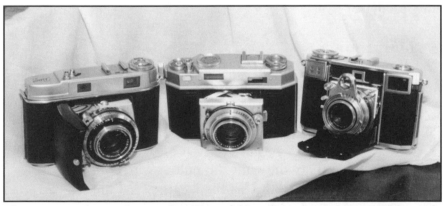

Three approaches to the popular 35mm folder all made in the mid-1950s: Agfa Karat (center), the oldest design, was modeled after the press cameras of the 1920s; the Zeiss Ikon Contessa (right) was a scaled-down version of the Super Ikonta of 1930, and the Retina IIc was the post-war upgrade of the 1935 Retina with metal bellows and interchangeable lenses.

The later C-series Retinas had a coupled rangefinder/viewfinder that changed the bright lines automatically, just as the M-series Leicas do.

The small "c" series camera, launched in 1952, introduced a front element that unscrewed and allowed for three interchangeable lenses: a tiny f5.6 35mm; a larger f4 wide-angle, and an f4 80mm portrait lens. These lenses have to be manually focused by scale, and the camera will not fold if the 80mm or the f4 wide-angle is in place. Also, you need a separate viewfinder for these lenses.

Retina I models (of whatever vintage) are all scale focus. All IIs are rangefinder cameras, and the IIIs add an uncoupled selenium-cell meter to the package. A delicate wire connects the cell to the indicator needle system and is not replaceable by mere humans, according to Mrus. That's why I no longer have a IIIc, but I do still have a IIa and a IIc in my collection. I take them fishing and hunting because they are easy to carry, and with no batteries they won't freeze up (as my EOS did). I also like the kind of "rounded" images they produce.

A DELICATE WIRE CONNECTS THE CELL TO THE INDICATOR NEEDLE SYSTEM AND IS NOT REPLACEABLE BY MERE HUMANS. . .

❦ COMPETITION

Kodak Retinas had competition from the start. First, following the Leica revolution, many makers of roll film folders were already scaling them down to use 35mm film, and the Retina's leap to leadership quickly spurred them on. Most, like those from Balda and Certo, seemed to share the same difficulties with combining rigidity and foldability as their earlier roll film folding brethren. Some folks swear by them, however, and also by the Welta and Weltini folding 35mm cameras. All of these have a single "normal" lens, typically 45mm or 50mm and usually f3.5 or faster.

A few folding 35mm cameras stand out. The best of these (at least in my collection) are the Zeiss Contessas. At this writing, the most pristine sell for around $200+, although you'll pay less for one with a dead selenium cell meter. Forget the meters, anyway. Selenium cells seldom are accurate after fifty years—which is how old most of these cameras are!

The Contessa of the 1950s is a tremendous camera for both black & white or color work, with its ultra-sharp, coated f2.8 45mm Zeiss Tessar lens. It also has the terrific wedge-prism rangefinder of the Super Ikonta, and I like it better than the Retina—though it

The Reitmeirs pose on their modern, homebuilt steam tractor. Contessa, f2.8 Tessar lens at f8.

is both heavier and a bit awkward to use. The awkwardness stems from the lens, which features three identical knurled rings stacked up for shutter speed (the outside ring), aperture and focusing for the coupled rangefinder. That is different from other cameras. The Retina, for example, has a more intuitive focusing knob, a small aperture pointer selector, and a shutter speed ring. Unlike the Retina, whose shutter cocks as the film is wound, one must also manually cock the Contessa's shutter before shifting the index finger to press the release.

ONE MUST ALSO MANUALLY COCK THE CONTESSA'S SHUTTER BEFORE SHIFTING THE INDEX FINGER TO PRESS THE RELEASE.

Both cameras have other peculiarities as well. They must be set at infinity or they will not close. The Retinas also have a film counter that must be set manually before you start shooting because, after you reach "36," it locks—apparently to prevent a film buyer from "stealing" the extra two frames from Kodak. This can be maddening if you forget to set the exposure counter and take three exposures, only to find the mechanism won't advance film anymore. It is

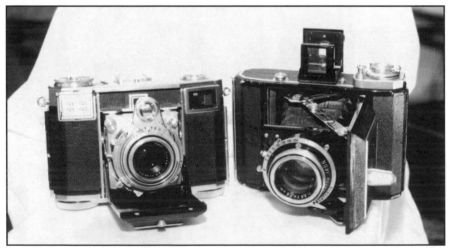

A pair of Zeiss folders. The Contessa of the mid-50s (left) takes 35mm film. The Ikonta of 1939 (right) takes 120 film and delivers a negative 3x as large for a camera no more bulky. Both fit in a jacket pocket.

also a pain if you are trying out the shutter to see if it works repeatedly at all speeds. The Contessa does not have *that* problem, but it will *not* cock unless the film sprockets are advanced—a double exposure prevention. Thus, to test a Contessa shutter you leave the back open and rotate the sprockets until you can cock the shutter, or put a spare roll of film in it to test operation. Because other tests (such as winding and rewinding) require having film in the camera, I keep a couple of sacrifice rolls of 120 and 35mm film just for this purpose.

❦ DON'T FORGET SOME OTHERS

Worth mentioning are some other 35mm folders, a field that the Germans dominated. Among them are the Voigtlanders. The Vito III of the 1950s is pretty rare (I've never seen one), but it followed the "drop-down door" model, had a coupled rangefinder and a superb f2 50mm Ultron lens.

The Vitessa is more often seen and is fairly pricey for this type (expect to pay nearly $200–300 for a good one). However, it is in many ways the most interesting folder of all. For one thing, it has a sort of double "barn door" opening that holds the lens perfectly rigid. It also has a unique plunger to advance film and cock the shutter. Plunge the plunger, press the release and you can run through a roll of film almost as fast as with a motor-drive, once you get coordinated. Apparently, these plungers sometimes remain in the "up" position, making the camera less pocketable. Some have built-in meters, others do not. They also came with a number of lenses—the f2 Ultron being the best.

Agfa made a lot of folders, as well—like the Solinette, Super Solinette (with a rangefinder), and the Karat. The Karats originally used special cassettes,

but after World War II the Agfa Karat 36 and identical Ansco Karomat were updated to use standard 35mm film cartridges. These cameras do not fold shut, but the lens springs outward when the lensboard is released by pressing a button. While I am not so sure about the Karat/Karomat shutter solidity, I believe their split-image rangefinder/viewfinder is among the best available. To be in focus, the bottom and top half of the images must merge (not just occupy a central portion of the viewed image as on other rangefinders). Thus they focus quickly, even in dim light. I am still looking for one that is both cosmetically and mechanically sound.

THESE CAMERAS DO NOT FOLD SHUT, BUT THE LENS SPRINGS OUTWARD WHEN THE LENSBOARD IS RELEASED BY PRESSING A BUTTON.

I have also had a few Zeiss Continas pass through my hands and, although they are plentiful, I think they are awful. I bought two of them that appeared to

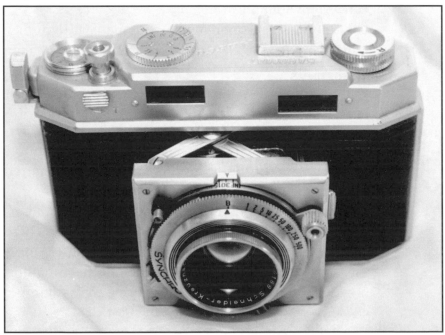

Agfa Karat (sold in the United States as an Ansco Karomat) has a spring-loaded front strut rather than a pull-open door. It also has one of the best rangefinders ever put on a camera (in my opinion).

be brand new, only to discover that the shutters quickly broke, they had inferior lenses and they had an uncoupled rangefinder. This is a silly way for a manufacturer to hold down costs. If you have trouble "guesstimating" distances, a rangefinder is helpful. However, with a built-in rangefinder that is not coupled to the lens, I was always focusing and forgetting to set the distance on the lens. Since there are so many good scale-focus cameras available and so many better rangefinder-equipped folding 35mm cameras on the market, I'd advise you to stay away from Continas (unless you want one to round out a Zeiss collection).

THIS IS A SILLY WAY FOR A MANUFACTURER TO HOLD DOWN COSTS.

8.
The Leica Revolution

FOLKLORE SUGGESTS THAT OSKAR BARNACK was an alpine hiker who wanted a small camera that would take superb photographs and, not finding anything to suit him, he "invented" the first 35mm camera. His invention, which became the Leica, was and remains the best viewfinder 35mm ever built. There are some who'd argue every one of those points. It is true that 35mm cameras were marketed before Barnack ever considered the format. It's also true that a lot of cameras—including some of the myriad of Leica clones—had better features than this seminal design long before Leica adopted them.

HIS INVENTION, WHICH BECAME THE LEICA, WAS AND REMAINS THE BEST VIEWFINDER 35MM EVER BUILT.

However, a lot of what Leicaphiles believe is true. Barnack was head of the experimental department of Ernst Leitz, a scientific instrument and binocular maker, and so had excellent mechanical and optical resources. And he *did* want maximum quality from minimum size. Therefore, 35mm cine film seemed a good way to achieve that—after all, what gets blown up bigger than images on a movie screen? Although his first designs date from 1913, it was not until after World War I that he had a chance to experiment with the concept. In 1923, thir-

Compact size silent shutter and interchange-able lenses made Leica the "photo-journalist" camera when intro-duced in 1930.

ty-five prototypes were built and fitted with a 50mm lens. They took 24mm x 36mm images, which became the standard 35mm negative size, just as the 50mm lens became the so-called normal focal length for the format.

The Leica (**LEI**tz **CA**mera) was first sold in 1925. In 1930, Leica pioneered interchangeable lenses via a screw-thread. Once again, their choice of 35mm, 50mm and 135mm focal lengths became the 35mm format "standards" for wide-angle, normal and tele-

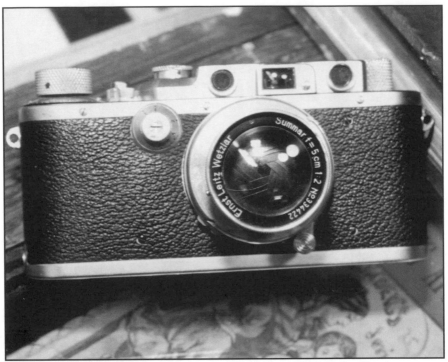

Classic Leica IIIa (thread-mount) camera, made in 1935 and still going strong.

photo lens photography for decades. In response to
the introduction of the Zeiss Ikon Contax with its
long-base coupled rangefinder (which many felt was
more accurate), Leica added a coupled
rangefinder in 1932. Contax adopted a
single window, combining the range-
finder and viewfinder in 1934—twenty
years before Leica followed suit. In
1954 Leica introduced the M3, which
(like the Contax) used a bayonet mount
for faster lens changing, and finally had a combined
rangefinder/viewfinder window. Leica also introduced
bright-frame finders that shifted automatically when
different lenses were mounted, thus eliminating the
need to use separate viewfinders.

IN 1954 LEICA INTRODUCED
THE M3, WHICH (LIKE THE
CONTAX) USED A BAYONET
MOUNT FOR FASTER LENS
CHANGING. . .

Several books describe in aching detail which
Leica models offered which features (the M2 and M1
came out *after* the M3, for example), but suffice it to

say that in 2001 the Leica M6 is still much the same camera as the M3. More importantly, the Leica was designed to be a flexible system camera and this set the stage for everything that was to come in 35mm cameras, and later in medium format equipment, as well.

My good friend, photographer Jon Blumb, has for years been a user of classic M-series Leicas, which he chose as his 35mm system. He does medium format studio and commercial work, but as a dedicated outdoor photographer, he needs the portability of a 35mm rangefinder. He settled on Leicas because they are superb opto-mechanical instruments. Moreover, they seem to work forever and (if he needs help) Leica repair specialists are available in virtually any city (small or large) around the world. Blumb's experiences and photos grace the following pages.

Chairs Waiting for A Picnic. Atchison, KS. Taken with a Leica. (© Jon Blumb)

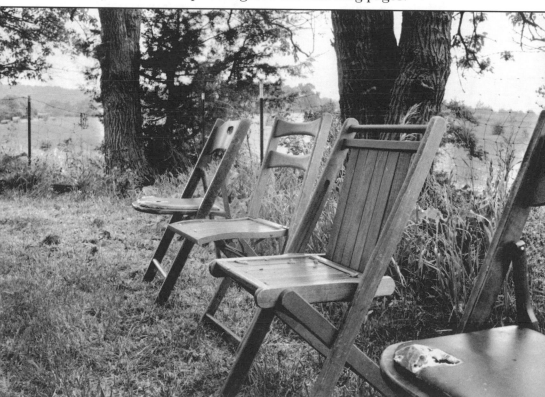

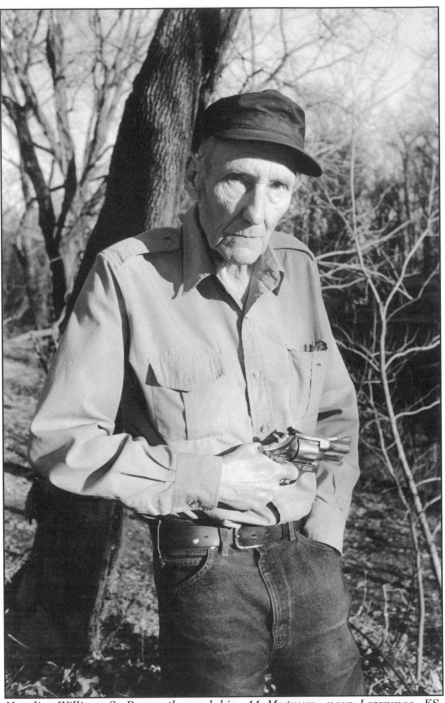

Novelist William S. Burroughs and his .44 Magnum, near Lawrence, KS. Photographer Jon Blumb still uses a forty-three year-old Leica M2 for much of his photojournalism work. (© Jon Blumb)

❦ THE LEICA IN USE

by Jon Blumb

Leica screw-mount cameras were the original compact camera, and like a modern point and shoot, a Leica IIIc, IIIf, or IIIg is small and lightweight. When equipped with a collapsible 50mm Elmar lens, a Leica fits easily in a pocket. A savvy Leica photographer can prefocus and preset the exposure for a favorite film and be prepared for a quick "grab shot." When the Leica came on the market, this approach to photography was the norm, since nothing was "automatic" or easy. These early Leicas can be carried inconspicuously in the hand or carried close to the chest. A minor focus correction or exposure tweak may be all that is necessary before releasing the shutter.

Compared to the screw-mount cameras, the M series makes winding, focusing and composition even easier. There is a single rangefinder/viewfinder window, a bayonet mount to change lenses faster and

COMPARED TO THE SCREW-MOUNT CAMERAS, THE M SERIES MAKES WINDING, FOCUSING, AND COMPOSITION EVEN EASIER.

even bright-line screens that appear when you change lenses so you don't need auxiliary viewfinders. These cameras are the epitome of good industrial design; they never go out of date, and even the most recent model feels the same in use as the original. Since the first M3 in 1954, these cameras have been improved internally and refined, but there has been little need to alter the original dimensions and style. The M4, M5 and M6 use batteries for metering, but everything else is mechanical, so you are never left holding a "dead" camera when batteries drain in the winter. Various power winders have been offered, which are nice aids for uninterrupted bracketing and focusing, but they add weight, bulk—and batteries. I often skip the winder if I'll be carrying a camera and lenses a long way or on airline trips where I can only carry a limit-

ed amount of gear. Leicavits are a lighter, mechanical alternative. These have rapid-winder baseplates that are manually operated so as not to make the photographer lower the camera from the eye and lose concentration while advancing the film.

Both thread and bayonet-lens Leicas are "systems cameras," designed to be expandable and to offer reflex viewing when equipped with a Visoflex housing. That turns the rangefinder Leica into a single lens reflex, allowing the photographer to see exactly what the lens sees. This is extremely useful when using a long telephoto or close-up lenses. The firm was very wise about light meters, too. There must have been considerable pressure for a built-in light meter in the '50s and '60s,

THIS IS EXTREMELY USEFUL WHEN USING A LONG TELEPHOTO OR CLOSE-UP LENSES.

Trout fisherman angling for cutthroat trout in Alberta, taken with a 28mm Leica Elmarit wide-angle lens. (© Jon Blumb)

but selenium cells were subject to a limited lifespan (I don't know if this was proven at the time), and Leica bucked the trend of building-in the meter by making detachable meters that fit in the accessory shoe, complete with booster cells for low light. These meters for the M cameras are "semi-coupled" to the shutter speed dial, so the user can set the shutter speed on the meter and the camera simultaneously. With this accomplished, the user has only to glance at the needle on top of the meter and manually transfer its f-stop indication to the lens immediately below. This is a clever design, which also has the benefit (appealing to purists) of gently educating the user to the relationship between shutter and lens settings and common lighting conditions, much like using a handheld meter.

LEICA BUCKED THE TREND OF BUILDING-IN THE METER BY MAKING DETACHABLE METERS THAT FIT IN THE ACCESSORY SHOE. . .

When I bought my first Leica, an M3, I was used to the match-needle metering system in my Nikkormat, which was quick and easy with through-the-lens metering. I did not mind learning the Leica MC system. The more I used it, the more I learned about associating light conditions with exposure settings. I was shocked to realize that I hadn't been paying attention to this association because my Nikkormat system was so convenient. Leica was wise not to integrate the meter into the camera body as did Zeiss and other competitors, because those cameras would have had a useless eyesore permanently attached once the selenium cell died. Instead, taking their time, they brought out a through-the-lens meter with the M4 camera that uses a more accurate and reliable CdS cell. This gives the user the option of not having a meter attached to the top of the camera if a handheld meter, on-camera flash exposure, studio flash, or other method of getting the correct exposure is pre-

View from Scottish Inn. A 35mm lens was used on a Leica M2 with the photographer's favorite emulsion, Kodak Plus-X. (© Jon Blumb)

ferred. Thus, the purity of the design was preserved, and the IIIf, IIIg, M3, M2, and M4 bodies are still much sought-after cameras.

This meter example illustrates the thoughtful approach behind Leica design. Some call it conservative and stubborn. I call it thorough and wise, because nearly fifty years after its introduction, the Leica M system remains a viable option for the working professional. The lenses remain in production, though most have been updated over time, so a new lens can be added to an existing outfit with seamless ease. Today's latest M6 camera body can use the photographer's favorite old lenses with the new convenience of through-the-lens metering and flash metering. Likewise, used lenses and cameras are always available to fill in a gap in an outfit, often at a lower price

than the newest equipment. The classic Leica M lenses include 21, 28, 35, 50, 90, and 135mm focal lengths. Recent designs include 24, 75, and the latest 35/50/90 multifocal lens. As this lens is set to those three "standard" focal lengths, a bright line appears in the finder to tell you what you are encompassing with that view. Leicaphiles often own just these three "core" lenses. New, too, are the aspheric designs in the classic focal lengths.

Lens Quality. The Leicas feature honest, dependable lenses that will never let a photographer down. If you can focus them, you will have a sharp image. They are compact because they do not need to be "automatic" (i.e., able to open wide for viewing and focusing as on an SLR). They are functional objects of great aesthetic beauty as well. Moreover, the company offers numerous specialty designs, complete with their own glass formulae, planned right down to their matching lens hoods. Many enthusiasts rave about the impact of a slide show made with Leica lenses, and there's no denying that; but the thing that originally convinced me, and that I still rely upon, is the quality of a black and white enlargement. I remember the first time I critically analyzed one of my Leica 8" x 10" prints of a negative taken with a 50mm Summicron. I was bowled over by the detail, and I'm not talking about depth-of-field. The photo was of a friend's face in profile, and every whisker in his cheek was visible and sharp!

THE LEICAS FEATURE HONEST, DEPENDABLE LENSES THAT WILL NEVER LET A PHOTOGRAPHER DOWN.

Leica lenses offer a "look" that is very subtle. Even the areas that are not in focus look good. The circles of confusion in a background are not a flaw; they are pleasant to see and a convincing photographic effect. (Many Zeiss lenses have this same kind of effect, especially on Hasselblads.) However you describe it, it's obvious that these lenses are very well designed and

Blumb used the Leica M2 and a 35mm Summicron lens for this shot of a Scottish guide using a scope to locate deer before the stalk begins. (© Jon Blumb)

built. Have you ever noticed a ragged or crusty effect in the background of a photo taken with an inexpensive zoom lens of a point and shoot camera? There's no doubt that some lenses just can't render images as well as other lens designs. They may be able to get the main subject in adequate focus, but the effect is just not beautiful. I'm not saying that such an effect is exclusive to Leica lenses or equal in all focal lengths and designs, but it is something I like to be confident in. This is especially important in low light conditions when you want 11" x 14" and 16" x 20" enlargements.

Compact and Portable. These attributes have always been primary to the Leica. While the slab-like look of an M camera with its slightly off-center lens may not appeal to everyone at first, it is still a practi-

cal size and shape. It is balanced and made all the more sturdy by virtue of the bottom loading system, which eliminates the need for a hinge and door that opens end-to-end. The M body with a collapsible 50mm Elmar lens fits in a pocket or can easily be worn inside the front of a coat or sports jacket, protected and unobtrusive yet ready at hand. I often carry two, one for color and one for black and white. I adjust the straps so one can hang above the other. Both are strapped around my neck but tucked inside my coat or vest. My preferred lenses are 35mm, a 50mm or a 28mm, depending on the subjects and distances I anticipate. Sometimes I choose a 21mm because I can interchange the lenses when I need them. The lenses are so small that I can carry a few extra in a pocket, pack or bag. I like to use Leica's back-to-back rear lens rings, which eliminate having the lenses knock against each other (simply tape two rear lens caps together to make this gadget for any brand of lens).

THE LENSES ARE SO SMALL THAT I CAN CARRY A FEW EXTRA IN A POCKET, PACK OR BAG.

Usage Tips. Remember to pre-meter and prefocus, so you're "in the ballpark" when a subject or action comes along. I usually try to remember to reset my focus to about 15' after I take close shots, just to avoid confusion when starting in again on an average distance subject. I prefer f8 for most photographs, and then adjust the shutter speed accordingly. If you like hyperfocal focusing, there are clear distance charts right on the Leica lens barrels, which you can study and use. I feel that any photo looks best when it has a point of deliberate focus, so I recommend critically focusing on the most important subject in the photo. If it is hard to decide, focus ⅓ of the way into the scene to make the best use of your depth of field.

Compared to a large SLR body and its lens, the Leica M camera is unobtrusive and easy to tolerate

when you want to carry it all day. If you want to accomplish a lot of work, combine two M bodies with an SLR body and a 70mm–210mm or similar zoom lens (and a 60mm or 100mm macro,) and you are prepared to thoroughly document your travels or to illustrate an article. Just don't expect to run any distances or squeeze through crowds carrying all that gear. The die-hard M purists would prefer to carry a 90mm and 135mm lens rather than the SLR and zoom. A Dual Range Summicron f2 50mm is a good alternative to the macro lens if you like to take details. In its close range with the auxiliary finder attached, it covers the 19" to one meter range. Remember to use the right lens hood with every lens you have, whatever the brand. A lens hood will do more to improve your photos than a filter. I am of the opinion that lenses are designed to function perfectly without any filter in front of them, so I only use filters for color correction or polarization (usually in the studio). And I always use lens hoods, especially when I have a filter on the lens!

REMEMBER TO USE THE RIGHT LENS HOOD WITH EVERY LENS YOU HAVE, WHATEVER THE BRAND.

A Leica M camera is quiet, having a cloth shutter and no mirror system, and it makes a satisfying "snick" sound when the shutter is released. It's funny, but to the uninitiated, a Leica may look modest and unassuming. Most people know the big SLR names and may not be familiar with the Leica, but some can just tell that it is a serious piece of gear. I get a kick out of how impressive an M camera can look when I hand one to a friend or acquaintance to take my photo. It always looks like that person knows what he or she is doing. It may take a minute to point out the controls, but the photos always come out fine.

Close-ups and Secret Codes. Leica developed a fantastic system for portable photography to get around the problems of photographing small objects

or using long telephoto lenses inherent in a rangefinder camera. But this wasn't a major concern for a company that also manufactures microscopes and medical equipment! Leica used to use five-letter codes for these accessories that are pretty entertaining. The idea was that dealers ordering these accessories could simply use the code word to get exactly the right piece of equipment.

Basic macro capability was achieved with extension tube and finder combinations called, respectively, NOOKY, SOOKY and SOMKY. Precise framing and focus was the job of the BOOWU, an accessory viewfinder. Numerous specialized extension tubes were offered to get photos of small objects. There were also the MOOLY windup motor for III-series cameras, the VIDEO finder, VALOY enlarger, the CEYAL flash gun and the RIFLE telephoto lens and camera mounted on a shoulder stock—to name a few favorites. (My favorite code name is the BOOWU, but I can't get my dog interested in doing copy work!)

MY FAVORITE CODE NAME IS THE BOOWU, BUT I CAN'T GET MY DOG INTERESTED IN DOING COPY WORK!

Later, the Leica started describing the gear instead of using codes: The Visoflex housing is a reflex viewing unit that fits between camera and lens, in effect converting a rangefinder camera to an SLR for through-the-lens viewing. With the Visoflex, a photographer who owns two camera bodies can use them like film holders or backs—one for black and white and one for color. The best reference book for this material is *The Leica Collector's Guide* by D. R. Grossmark, published by Hove Foto Books of Hove, East Sussex, UK (now available only on the used book market). Still, the number code for current products is not nearly as much fun as the old acronymic code.

9.
Leica and Its Offspring

*L*EICAS REALLY DID REVOLUTIONIZE PHOTOGRAPHY. Smaller and more unobtrusive than most cameras of the day, they set trends that are still followed—knurled knobs on the top plate to advance and rewind cassette-loaded film, fast lenses, eye-level viewing, and a coupled rangefinder all suggested spontaneous camera work that few other types of cameras could emulate.

By the 1920s, some makers had developed cameras like the vaunted Ermanox, which used tiny glass plates and an incredibly fast (for the era) f2 lens to allow for exposure in a dimly lit bistro—even with the slow film emulsions of the day. In fact, they advertised "what you see, you get."

BY THE 1920S, SOME MAKERS HAD DEVELOPED CAMERAS LIKE THE VAUNTED ERMANOX. . .

The handheld Leica went beyond the Ermanox by offering twenty and even forty exposures on a roll of film. Now, one could try several shots from different angles or with different exposure times by merely twisting a knob. While small, the Leica also permitted handheld exposures of $^1/_{10}$ of a second, if one was a careful practitioner.

At this time, photojournalism was in its infancy and "fly on the wall" photography suddenly became very hot stuff indeed. Brassai, Cartier-Bresson, Capa

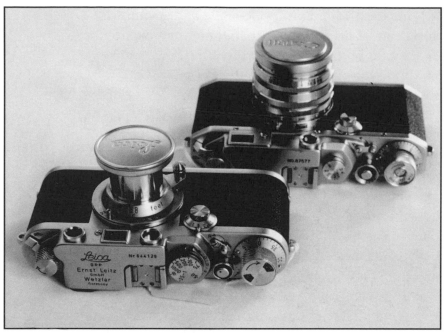

A pristine 1938 thread-mount Leica with collapsible Elmar Lens, and a Canon made in the 1950s with a sharp Canon Lens. It's hard to tell the difference without reading the engravings.

and Eisenstatdt literally changed the way we saw the world—all because of a handheld camera that could be focused in dim light and had fast lenses that (because of their short focal length) had enough depth of field to make "grab shots" with zone focusing a real possibility. As a result, thread-mount Leicas were cloned all over the world.

❦ THE LTM COMEBACK

Even today, Leica thread-mount (LTM) cameras are being produced in an upgraded form in Japan. The Yasuhara company makes a body to take thread-mount lenses from Leica, Canon and others, and offers modern internal light metering.

Cosina, who has revived the Voigtlander name, now makes a pair of LTM cameras called Voigtlander Bessa. One requires an auxiliary viewfinder for every lens and zone- or scale-focuser. Four amazing lenses,

a 12mm and 15mm ultrawide-angle and 25mm wide-angle can be used, along with a 35mm, 50mm, 75mm and 90mm portrait lens. For the latter, however, you'd better look to the Bessa RF, which has a coupled rangefinder/view-finder as well as a good, internal light meter. The neat thing is that all Leica or Canon LTM lenses will work on this new, all-mechanical body that has a $^{1}/_{2000}$ of a second shutter speed, and that the new Voigtlander lenses can be used on Leica or Canon bodies. This camera may make buying a Leica or Canon thread-mount body and lenses redundant for the classic camera practitioner. Why use a fifty year-old body when a new one is available that takes those classic lenses?

YOU'D BETTER LOOK TO THE BESSA RF, WHICH HAS A COUPLED RANGEFINDER/VIEWFINDER...

Another Japanese camera maker, Fuji, is offering the Hexar RF, which is essentially like an M-series

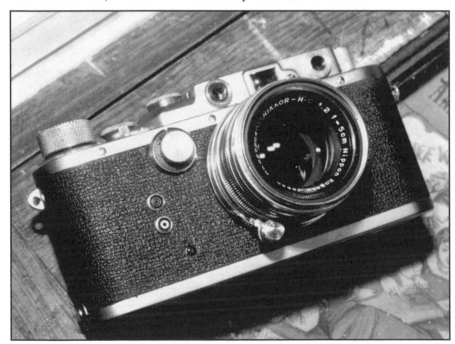

Leica? No—a Nicca, c. 1952, a Japanese Leica thread-mount "copy" fitted with a superb Nikon lens. These cameras were also sold by Sears, as "Towers" and cost as much as prewar Leicas. The Canon rangefinder is another Leica clone worth investigating.

Leica. However, it uses an electronic shutter, which—good as these are—requires batteries.

Yet, none of these is a Leica. Made to close tolerances and having true cult status, a screw-mount Leica IIIf may not be the best choice for someone looking to try classic 35mm photojournalism, though, because collectors keep Leica prices too high for the thrifty. Personally I'd pick the new Voigtlander Bessa with its affordable wide-angle lenses.

If you *must* have an LTM camera, Canon clones might be a better choice (price-wise)—or even the Towers made by Nicca, one of the best Japanese Leica imitators. Tower cameras, a Sears brand, were generally sold to amateurs rather than pros, so they've had far fewer films run through them. The ones I've seen were pristine and had the same silky mechanical feel that makes a well-tuned Leica such a desirable acquisition. They were not exactly cheap, either.

Some Leica copies have a combined rangefinder/viewfinder—something Leica never got around to until its last IIIg model. Some have backs that swing open for loading (a vast improvement over the original). Although Jon Blumb (see page 77) notes that the bottom loading Leica scheme makes for a more solid camera body, I find them awkward. Loading a classic Leica requires that you remove the bottom plate, thread the film in through a small drop-in channel, and then secure the bottom. I prefer the Zeiss Contax system, where the whole back lifts off. But both are clumsy, however, when they are compared to the hinged, swing-open back of modern 35mm cameras.

LOADING A CLASSIC LEICA REQUIRES REMOVING THE BOTTOM PLATE. . .

🌱 COLLECTING CLONES

There is a collecting specialty of finding Leica clones, imitators and fakes. Clones, like the Canon LTM cam-

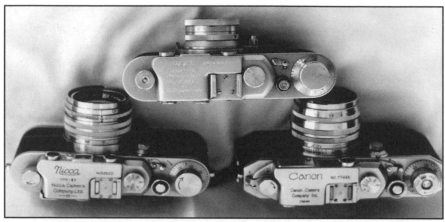

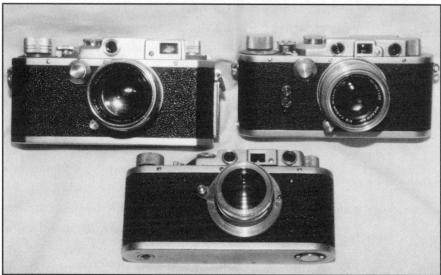

Three of the "best" Leica clones: pre-World War II FED made in Russia under license from Leitz, and a Canon and Nicca, both made twenty years later in Japan.

eras, are not illegal copies and some clones, like the Niccas, may have been made with Leitz's cooperation.

A LARGE NUMBER OF FAKES, COPIES AND CLONES HAVE COME OUT. . .

They were not "faked" as Leicas, in any event. But a large number of fakes, copies and clones *have* come out of the former Union of Soviet Socialist Republics and many of them—like the "legal" FEDs—are a collecting subset these days. Some are surprisingly good! There are ways to check Leica authenticity, but that's beyond the scope of this book.

10.
Leica's Real Competition: Contax

*L*EITZ HAD PLENTY OF COMPETITORS, and the most aggressive of these (before World War II) was Zeiss. During the Depression, the Carl Zeiss Institute supplied lenses to a vast number of camera companies. As these buyers weakened, the lens maker hit on a simple idea: Form a consortium, create a new "brand" (Zeiss Ikon) and sell pretty much the same cameras—but at a profit, by eliminating the weakest designs and discovering economies of scale. Zeiss historians can argue about the minutiae, but the fact is that the first "new" camera they came up with was the Contax—a focal-plane shutter, interchangeable lens 35mm camera that went head-to-head with the Leica.

Because Leica had patented its horizontal rubberized cloth focal-plane shutter, Zeiss developed a metal focal-plane shutter that traveled vertically instead of horizontally—a system considered the norm these days, but a first back then. Zeiss also used a long-base rangefinder that many feel snaps into focus a lot better than the Leica system. The second Contax model, introduced in 1934, also utilized one window for both focus and framing (unlike the Leica's spilt windows) and had a

ZEISS DEVELOPED A METAL FOCAL-PLANE SHUTTER THAT TRAVELED VERTICALLY INSTEAD OF HORIZONTALLY.

bayonet mount, which may be faster to use than a thread-mount when changing lenses. The Contax also used a little focusing wheel (for the 50mm lens only) that is retained on today's electronic Contax G-series cameras made by Yashica.

The classic Contax has some unpleasant quirks, however. The worst of these is that you *must* hold down the infinity lock to allow the focus to move initially, and the wheel is slow. Most Contax users just focus with the lens ring, as they must do with the wide-angle and long lenses anyway.

❦ LENSES

Contax initially offered far more lenses than did Leica. In 1934, for example, a Contax user had a choice of

▣ *Russian Lenses*

There is one thing to be said for the Russian lenses—not all of them will fit on Contax bodies. For example, the f2.8 35mm, an almost indispensable focal length for this kind of photography, will fit the prewar Contax I and II bodies but not the postwar versions. The f2 85mm Jupiter (a great focal length that is useful for candid portraiture or photographing stage shows by available light) only fits properly on one of my Kiev bodies, not all of them—and not on any Contax body I own. Conversely, all of my Contax lenses fit perfectly on the Russian bodies. A close examination shows that the machining tolerances are much more precise on the German-made cameras, which makes for easy lens interchangeability. However, I am a committed Kiev user and plan someday to experiment a bit with FED, NKVD and Mir cameras—all of them Russian Leica thread-mount clones—although I believe the issue of lens/body interchangeability is also true with those cameras.

The fact is that the Russians stuck with those 1936 designs right up until 1980 and seem to have produced tons of them—for both domestic use and as exports to get hard currency. Thus, you are more likely to find a varifocal viewfinder that comes from Russia than its German counterpart, and you are far more likely to find the 35mm and 85mm focal lengths in a Contax mount (at an affordable price!) than you will lenses from either Dresden or Stuttgart. Just make sure everything lines up and fits properly before you make final payment.

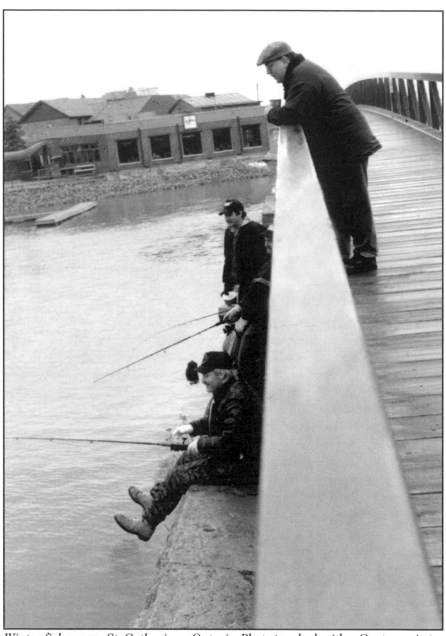

Winter fishermen, St. Catharines, Ontario. Photographed with a Contax using a 21mm Biogon lens.

twelve focal lengths from 28mm–500mm (with special viewfinders for each focal length other than 50mm), while the Leica fan had just eight focal lengths from 35mm–135mm to choose from. Even by the beginning of World War II, Leica had not caught up.

But "focal length envy" is hardly a reason to choose one system over another. The fact is, any viewfinder camera has serious limitations as to the lenses it can use effectively. If you learned most of your photography with a single lens reflex 35mm and color slide film, you will have learned to crop in the camera—after all, the SLR's viewfinder shows you exactly what the lens sees. But in a rangefinder camera, whose viewfinder is situated above the lens and off to one side, inaccuracies are bound to occur. For one thing, working any closer than about 4" involves problems with parallax (you look at one thing, but the lens is a little lower and maybe off to one side, so you photograph something else). Some cameras (like the landmark Olympus XA) have extra lines to show how to shift your view to compensate. I have several auxiliary viewfinders for my Contaxes that actually tilt. The viewfinder for the three-lens close-up Contameter set is designed to tilt more to adjust for each closer-focusing auxiliary lens. A multifocal viewfinder I use for the wide-angle through telephoto lenses has three settings for the 135mm lens: infinity, 10' and 5'. The shift for a 28mm or 35mm wide-angle lens can be set for infinity or close. No in-between settings are offered because they don't need to be focused as critically.

This tells you something about the nature of the lenses used in 35mm photography. Wide-angle lenses take in so much and have such good depth of field that exact focusing is not all that critical except, perhaps, when shooting wide open (when depth of field dimin-

SOME CAMERAS (LIKE THE LANDMARK OLYMPUS XA) HAVE EXTRA LINES TO SHOW HOW TO SHIFT YOUR VIEW TO COMPENSATE.

Independence Day, 1999, Beacon Hill, Boston. Photographed using a Contax IIIa camera with a 50mm Sonnar lens.

ishes greatly on any lens). Put another way, most photojournalists today consider the 35mm focal length the "normal" view for a 35mm camera. They can work fairly close yet still get enough of the subject's surroundings to capture a scene; you can even be a little off and still get a well-focused image.

Anything longer than a 135mm focal length (a 2–3x magnification) really requires a reflex housing on a rangefinder camera. For years, *Life* magazine's leading photographer Alfred Eisenstadt used Leicas for his 28mm, 35mm and 50mm lenses—and sometimes used a 75mm or 90mm "portrait" lens on them. But when he wanted to go telephoto, he switched to a Nikon SLR. That's still a good plan for several reasons. Besides making it easier to focus and frame a telephoto accurately, an SLR usually allows one to meter through the lens—far more accurate than guessing exposure from hundreds of yards away.

BESIDES MAKING IT EASIER TO FOCUS AND FRAME A TELEPHOTO ACCURATELY, AN **SLR** USUALLY ALLOWS ONE TO METER THROUGH THE LENS. . .

Conversely, SLR lenses shorter than 35mm require a "retrofocus" lens design. Without this, the rear lens elements would interfere with the mirror in the reflex system. This makes the SLR camera even more bulky and obtrusive, and since one uses a wide-angle mostly to work in tight quarters (such as a narrow alley in a souk or bazaar if you are an aggressive travel photographer), a bigger and more obtrusive camera can get in the way of that "fly on the wall" quality that Leica-style photographers like to practice. My 1954 Contax and its tiny 21mm wide-angle still fits in a sports jacket pocket (even though it pulls that pocket out of shape with its weight)! I "fell into" this Contax outfit through a fellow reporter whose widowed mother wanted to give Dad's camera a good home. Besides a IIIa body, the outfit had an f4.5 21mm Biogon, an f1.5

50mm Tessar and an f4 135mm Tessar with all the filters, finders and accessories needed. It also came with the original sales brochures, instruction books and even a copy of "Contax Way," one of a handy series of guides published to show photographers how to get the best from their cameras.

Slides taken with it on a visit to Seattle seemed to be better than work I was doing with a modern auto-exposure, auto-focus professional 35mm system. Perhaps it was concentration that made me "see" better pictures, or perhaps it was that prime lenses are simply crisper and sharper than zooms (which have so many lens elements in them that the potential for flare is increased). Whatever the reason, I decided that rangefinder 35mm cameras would be my prime instruments in that format; and I decided that using old cameras was enormous fun. Which it is—until you drop them!

I DECIDED THAT RANGEFINDER 35MM CAMERAS WOULD BE MY PRIME INSTRUMENTS IN THAT FORMAT. . .

❦ PERILS AND PITFALLS OF THE RANGEFINDER

One thing that those who tout classic 35mm rangefinders *never* tell you is that a sharp drop can knock the rangefinder prism out of whack. A major drop can shatter them, as well. That's what happened to my baby. Had it been a Leica M series, the factory could repair it. However, these obsolete Contaxes (or the earlier thread-mount Leicas) can only be fixed by cannibalization. I even supplied a "parts" camera for the prism transplant and still waited a year to get my camera back from the shop. (*Memo to me:* Find a new repair shop!)

The prewar Contax II and III (the latter has a coupled exposure meter sticking out on top) have a better chance of finding spare parts because of the Russians—and thereby hangs a tale. Zeiss Ikon

The Roycroft Inn near my home is a favorite spot for lens testing because its architectural lines and textures help reveal any distortion or other lens aberrations. This shot was taken with the Kiev outfit shown on the next page.

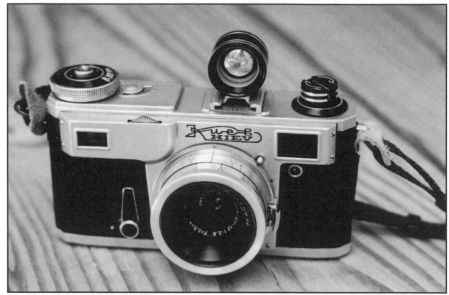

The Kiev is a Soviet-made clone of the prewar Contax rangefinder. It is fitted with a Jupiter 35mm lens, a copy of the wonderful Zeiss Biogon. An auxiliary viewfinder often is needed on these early cameras, since their built-in viewfinder only shows the "normal" 50mm lens view.

Contaxes were made in Dresden, which, after the war, became part of East Germany. For a few years, Contaxes marked "Zeiss" came from there. In the meantime, most of the company's technical people fled to the West. There they established Carl Zeiss in their Stuttgart factory (my Contaxes were all Stuttgart models), made some changes to the camera and began suing the East Germans over use of the Zeiss name. Around 1950, the machinery (and several Zeiss technical people) went to Kiev in the Ukraine where the prewar Contax II and III continued to be made right up until 1980 under a variety of Kiev model numbers. The same company, Kiev Arsenal, produces a copy of the Hasselblad, and some of that gear is interchangeable with the Swedish classic, too.

IN THE MEANTIME, MOST OF THE COMPANY'S TECHNICAL PEOPLE FLED TO THE WEST.

As I waited and waited for my Contax to be repaired, I bought other Contax bodies and eventually picked up a couple of Kievs as well. The Kiev 4 AM

model seems to be aluminum—it was lighter than my Contaxes, anyway. Like the Contax II, it has no meter (which would just get in the way, for reasons explained in chapter 14). It even has a rewind lever to make reloading a tad easier. The best thing is that a Kiev can be obtained (at this writing) for about $100–$150, complete with an f2 50mm Jupiter or an f2 53mm Helios lens—both of which take pretty good pictures. It's as cheap a way to get into 35mm rangefinder photography as there is today.

If this style of camera work suits you, upgrading later is always possible. You also can become a Russian camera fanatic/collector for about ¼ the outlay of a Contax purist or ¹⁄₁₀ the outlay of a Leicaphile (for they made several Leica copies in Russia, too). I won't start a war arguing which cameras are most likely to last the longest without repair or which brand is the best investment. The Russian models are still a cheap way to learn if this kind of photography suits your style, and (some repair experts tell me) a lot of prewar Contax IIs have Kiev workings when you open them up.

IF THIS STYLE OF CAMERA WORK SUITS YOU, UPGRADING LATER IS ALWAYS POSSIBLE.

11.
Contax Accessories

IKE LEICA, THE CONTAX SYSTEM came with a host of accessories, starting with some of the best lenses ever made for a 35mm camera. The Tessar f1.5 50mm, especially the post-World War II coated version, is one of the sharpest lenses (wide open) ever designed. There is also an f2 Tessar, but I have not found that model as crisp as the f1.5 in over-all picture sharpness (something for which all Zeiss lenses are praised). There were f2.8 and f3.5 "normal" lenses, too, some of which folded flat to make the camera body more pocketable.

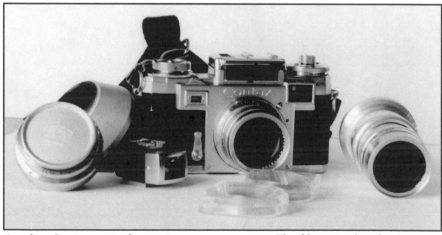

Another Contax unit showing some accessories. The filters in the plastic cases screw in, as does the metal sunshade. The viewfinder in front of the camera fits on the accessory shoe and is for the ultrawide 21mm lens on the left.

◙ Lens Selection

It's funny, but our first instinct as photographers is to get a telephoto so we can take "candid pictures" at a distance. As we mature in our craft, we want wider and wider lenses so we can work closer and closer to our subjects and show more of the environment in which they exist.

Wide-angle lenses were available in 35mm, 28mm and 21mm focal lengths, and a postwar 21mm Biogon with a maximum aperture of f4.5 is one of my favorite lenses. If you don't tilt it, it has no edge distortion, allows you to work very close to the subject and get the entire flavor of the world in which that subject works or plays.

Telephotos were limited to the f2 85mm Tessar and the 135mm in a Tessar design (and a somewhat cheaper Triotar). I own a prewar uncoated f2 85mm Tessar that is an amazing portrait lens and, with a lens shade, does not exhibit excessive flare. In the 135mm length, I'd choose the Tessars over the Triotars for maximum sharpness. If the Kiev f2 85mm lens fits your Contax or Kiev, it is probably equal to the Zeiss optic in crispness and that lovely "feel" when used as a portrait lens.

IF THE KIEV F2 85MM LENS FITS YOUR CONTAX OR KIEV, IT IS PROBABLY EQUAL TO THE ZEISS OPTIC IN CRISPNESS...

For the 1936 German Olympics, Zeiss developed a 180mm Olympic Sonnar, which used an accessory eyepiece that fit into the accessory shoe atop the camera. I've never seen these outside of books, but they were the longest lenses ever put on a rangefinder camera without some sort of through-the-lens viewing device (like the Visoflex). Zeiss had a 500mm, which was the longest available at that time that used such a reflex viewing system.

❧ ACCESSORIES

Viewfinders. Obviously, when you change lenses you must be able to view the scene properly. Until internal

masks and bright frame lines were adopted, accessory viewfinders were imperative. If you buy a classic wide-angle or telephoto lens for any "system" rangefinder camera, get the accessory viewfinder, too. There are a bunch of these: separate 35mm and 21mm for those focal lengths alone, and an 85mm/135mm finder for those two focal lengths together. The 135mm lines are inscribed inside the 85mm image. There were also Contax Albada finders that had lines for the 50mm and 135mm lenses, and one for the 50mm–85mm focal lengths that fit into the accessory shoe. I had one of those, but it was so dim as to be unusable.

Why a "normal lens" accessory viewfinder? Apparently, even in the 1930s, some folks could not see through the viewfinder window on the camera. The drill is to focus using the split-image and then shift your eye to the finder; this is not as hard as it sounds. In early thread-mount Leicas, you had two windows anyway (one for the viewfinder, one for the rangefinder), and the best 50mm finder ever made was sold as an accessory for those cameras. I now use a varifocal finder on my Contax/Kiev cameras that goes from 28mm–135mm focal lengths because I cannot see the edges of the frame (for the 50mm lens) in the regular viewfinder window with my bifocals on.

THE DRILL IS TO FOCUS USING THE SPLIT-IMAGE AND THEN SHIFT YOUR EYE TO THE FINDER; THIS IS NOT AS HARD AS IT SOUNDS.

Other Accessories. Contax had a myriad of weird accessories, including a single exposure back that had a ground glass and used tiny glass plates for scientific work, a stereo attachment that split the image into two on the film, and a variety of sunshades and filters. For close-ups, they had the Contaprox lenses and the more expensive Contameter, the latter being one of the snappiest (and most accurate) close-up systems ever devised for a non-SLR camera. The viewfinder has three settings that correlate to the three close-up

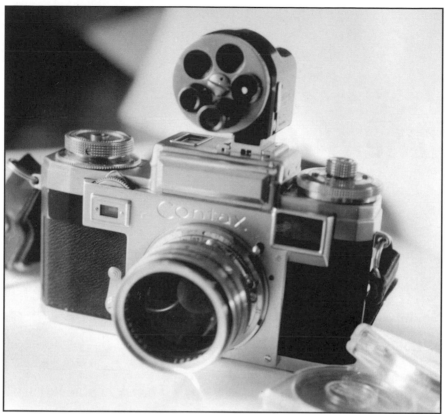

Contax with accessory viewfinder. The different lenses shift to show 28mm–135mm views.

lenses for distances of 20", 12" and 8" from the lens. The photographer screws the proper accessory lens onto the normal lens and then dials the setting on the viewfinder so it adjusts for parallax at that distance. It is accurate, and I've taken some lovely photos of tulips and crocuses using that system—a scheme that seemed, on paper, to be totally unworkable compared to a macro lens on an SLR camera.

12.
The Submini Minox

*I*T IS NOT CERTAIN THAT WALTER ZAPF designed his Minox camera with espionage in mind. When he began working on it around 1930, the 35mm camera was called "miniature" format and Zapf was just carrying that concept to a logical extension. However, when introduced in 1938, the Minox turned out to be the choice of intelligence agencies worldwide. And why not? It was small—about the size of a large cigarette lighter—and designed to fit comfortably in your hand. A cassette of film could take up to fifty exposures, and a remarkably small (and fast for its time) f3.5 lens that focused as close as 8" meant it could copy documents in the era before the office copier became universal.

IT IS NOT CERTAIN THAT WALTER ZAPF DESIGNED HIS MINOX CAMERA WITH ESPIONAGE IN MIND.

Zapf, a Lithuanian of German extraction, pursued his dream for years, finally seeing his tiny handful of photographic excellence built of stainless steel in Riga, Latvia, from 1938 to 1940, when the Russians who took over built a handful of "made in USSR" Riga Minoxes from parts on hand. Following World War II, Minox followed Zapf to Wetzlar, Germany, where the inventor had fled to work for Leitz during the hostilities.

From 1946 until the present, Minox has simply upgraded the original design, adding flash synchronization, meters and now electronic shutters. Three major changes have occurred. First, stainless steel gave way to aluminum bodies, then the lens was changed. The first postwar curved lens was a disaster, but the curved Complan remains a superb optic, and the new, flat lens, is equally sharp. The push-pull film advance has not changed, nor has the recessed lens (a built-in sunshade) or the built-in filters that slide in front of the lens (although these are now neutral density rather than the yellow and green that were so useful for black & white photography). The Minox design has been widely copied by a host of manufacturers, and the Minox cassette is still used by other submini brands.

FIRST, STAINLESS STEEL GAVE WAY TO ALUMINUM BODIES, THEN THE LENS WAS CHANGED.

Zapf, alive and well and in his 90s in Switzerland, today declares that a "spy camera" was not on his mind, just a tiny instrument that could and would be carried everywhere in a pocket or purse. He envisioned and created an entire system that would work together to produce sharp photos from a negative measuring 8mm x 11mm—about the size of a human

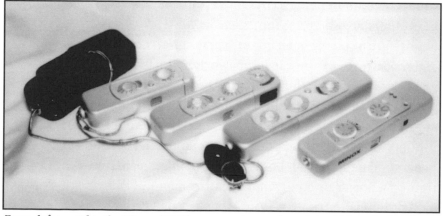

From left to right: the Minox 35 (the same size as the original Minox); the Minox B with selenium meter; the Minox C with its CdS meter, and the LX (the contemporary model offering auto-exposure).

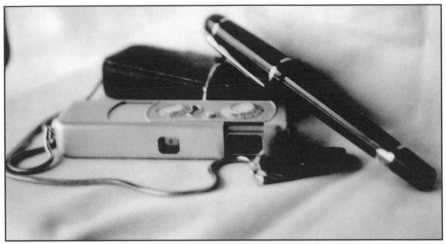

The Minox 3S shown with an attached measuring chain for ultra close-ups (and a pen for scale).

fingernail. Today, there are daylight developing tanks, Minox enlargers and even Minox slide projectors!

The tiny 9.5mm film meant a short focal length (15mm) lens could produce approximately the same angle of view as the "normal" lens on a 35mm camera. Since shorter focal length lenses give greater inherent depth of field, setting the Minox to 9' keeps everything in focus from 6' to infinity—handy if you wander city streets looking for interesting sights. Of course, close focusing means much reduced depth of field, so the most popular Minox accessory is the "measuring chain" with beads spaced at varying distances to help the close-up worker. In fact, close work is something the camera excels at—providing you measure carefully. In fact Minoxographers soon stop looking for "scenery" but become people photographers or close-up workers. The camera lens itself became a handy "notebook" to remember a restaurant or a flower or a particular feature of a building in a city you visited.

SETTING THE MINOX TO 9' KEEPS EVERYTHING IN FOCUS FROM 6' TO INFINITY.

To simplify matters, Zapf decided that an adjustable aperture was not necessary, thus all "spy"

Minoxes have an f3.5 fixed aperture. From the beginning, shutter speeds ranged from $\frac{1}{2}$ to $\frac{1}{1000}$ of a second so all one needed to do was select the proper speed for the available light, set the focus and shoot. The current LX model, introduced in the 1970s, has a $\frac{1}{2000}$ of a second top speed, as well as an accurate CdS meter and an "auto" setting that is pretty good at selecting the right shutter speed (although one can always override the meter).

My favorite Minox is the IIIs (called the Model A in Europe) made from 1948 to 1963. Tiny and meterless, it is still capable of being used with a miniature accessory flash (using AG 1 bulbs) or a small electronic flash gun in the later IIIs versions. That camera was also the first to use the sharp Complan lens many Minox fans deem the best of the lot. It was followed by

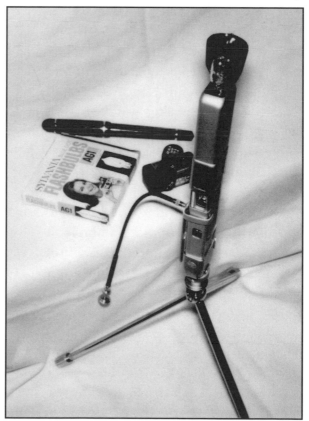

The Minox B, mounted on a tripod and fitted with its flash gun and shutter release.

the Model B (1958–76), the most common Minox of all, which has an uncoupled selenium-cell meter. Some forty years later these still can be fairly accurate in sunlight, since most of these cameras spent their time in fitted leather cases and the meter cells did not weaken with age.

The most expensive classic mechanical Minox (after the Rigas) is the BL of 1971–76, with a more accurate uncoupled CdS meter. The C (1969–79) is a long, skinny Minox that also was quite popular. It, too, has a CdS meter and was the first to have an "A" (automatic) setting—so it's probably outside the scope of our book, as are the LX and current TLX with their $1/_{2000}$ of a second electronic shuttered "automatic exposure" cameras.

❦ OTHER SUBMINIATURE CAMERAS

Subminiature cameras have been with us since the earliest days of photography. In 1900 there were tiny cameras that could be concealed in hats, neckties (the lens was the tie-pin) and even small plate cameras that looked like pocket watches. But, as the Minox became popular and the Cold War got underway, the whole subminiature field opened up, leading to the 110 cameras still made and sold today.

Most subminis, like Minolta, Mamiya, Steky and others, used 16mm film in their own cassettes. The expensive Tessina uses 35mm film loaded into its own special cassettes and the Yashica Atoron used the Minox cartridge. The Japanese Acmel still uses Minox cassettes. In fact they make at least one contemporary Minox camera that is re-labeled for the German company, and also the $1/_{3}$-size Leica IIIf. This could classify as a classic because it has a single shutter speed, a single aperture and fixed focus—making it a

MOST SUBMINIS, LIKE MINOLTA, MAMIYA, STEKY AND OTHERS, USED 16MM FILM IN THEIR OWN CASSETTES.

The Minox B, with its built-in meter, had the longest production run of all the Minox models.

tiny, jewel-like box camera that will set you back $400! (However, since a used Minox C can be had for less than $300 and a IIIs or B for around $150, you would be better advised to pick up one of those masterpieces and enjoy a variable shutter speed and a focusing range from 8" out.)

I have become enamored of the Minox, and I also have a couple of the all-mechanical early Minolta 16s cameras that are almost as nice. But the best part is the Minox accessories—a tiny tripod that fits in a pocket, a binocular clamp that turns a Minox into a "telephoto camera" and a daylight developing tank. In time, I expect to develop my own black & white Minox film then scan it and print it at home with an Epson printer. That may not be cheaper than using Minox Labs in New Hyde Park, NY, but I won't have to wait for ten days to see the results. I will continue to send color print film there, of course.

THE MINOX IS, IRONICALLY, THE MOST "NOTICED" CAMERA I USE.

The Minox is, ironically, the most "noticed" camera I use. I can shoot all day with a 35mm camera and no one seems to pay attention, but when I hoist a tiny Minox to my eye someone inevitably asks "is that spy camera?" Maybe Walter Zapf isn't kidding when he declares he just wanted a small camera you would always keep ready in your hand.

13.
The Twin Lens Reflex

*T*HE TWIN LENS REFLEX WAS NOT ONLY the most popular amateur camera around from the mid-1930s until the mid-1950s, but a mainstay of professional journalists as well. Why it fell from favor is no mystery—once the mass of advanced amateurs switched from black & white to color slide film, the cost of feeding one of these babies was staggering, compared to 35mm Kodachrome. Moreover, most TLRs have just one lens, making them appear to be less "advanced" than the interchangeable-lens 35mm outfits that take up hardly more space in a gadget bag and might even weigh less than a TLR.

THE CONCEPT IS WONDERFUL BECAUSE THE VIEWING LENS OFFERS A GROUND GLASS IMAGE THAT SHOWS YOU EXACTLY WHAT THE FILM WILL SEE.

Still, the concept is wonderful because the viewing lens offers a ground glass image that, like a view camera, shows you *exactly* what the film will see. The 2¼" square negative is also huge by 35mm standards, and thus extremely easy to work with in the darkroom. Not only are contact prints large enough to be stuck in albums and viewed comfortably, but you can crop that square for either vertical or horizontal treatment (and a lot of pros do just that today). For example, one can take a really good shot of a dam, crop it vertically for a mag-

azine cover, then print it either as a horizontal or smaller square format for a picture inside the book to help illustrate the story.

The TLR, unlike an SLR, does not black out the view at the moment of exposure, so it is probably best

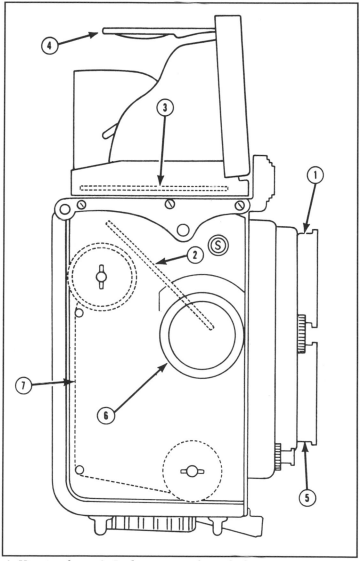

1. Viewing lens. 2. Light passing through the viewing lens hits the mirror angled to reflect it on viewing screen above. 3. Viewing screen. 4. Pop-up magnifier attached to hood aids with focusing. 5. Taking lens. 6. Focusing knob. 7. Film unrolls from spool, passes behind taking lens. (Diagram courtesy of Yashica.)

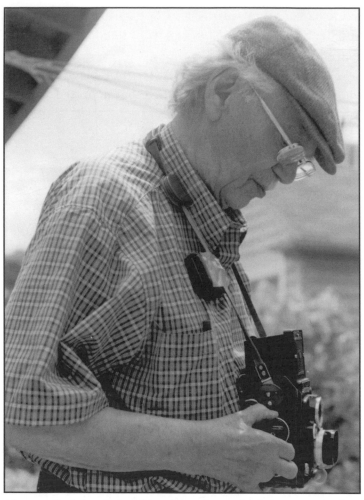

Above—Social activist Milton Rogovin worked almost exclusively with the Rolleiflex twin lens reflex. He said people are not intimidated when he looked down into a camera, but they became self-conscious when he "aimed" an eye-level camera at them.

Opposite, Top—The TLR seems to lend itself to scenery and a reflective kind of photography.

Opposite, Bottom—The Rolleiflex's waist-level viewing gives a somewhat different slant on this photo of a new colt and its trainer.

for portraits, fashion, children and pet photography. Of course, it is equally well-suited for scenics. Renowned documentary photographer Milton Rogovin said that "looking down into a camera, rather than aiming something at someone's face" made it possible for him to take remarkable photos of "the forgotten ones" in society. Rogovin devoted himself to "environmental" portraits of poor folks and working folks on four continents, taking pictures of miners, peasants, steelworkers and working-class neighborhoods, often pairing portraits of the people at work and in their homes. He believed his success was due in part

It is a personal project of mine to photograph this woodland stream in all seasons. Because there are no lenses to swap and it produces a large negative, the TLR is a good choice for scenic photography.

to the fact that "looking down into a reflex camera is less threatening than aiming a rangefinder camera at someone."

🍎 LENSES

The fact that most TLRs are limited to a fixed lens is not a major problem. Being able to blow up a portion of the 6cm x 6cm negative and still get good results almost obviates the need to carry a telephoto or a portrait lens. Sling on the camera, grab a couple extra rolls of film and a filter or two, and you are ready for a day afield.

Parallax. However, if you plan on taking serious close-ups, parallax again becomes an issue because the taking lens on a TLR is below the viewing lens. At 20" (with a close-up attachment) you'd be looking at the flower but photographing only the stem. This can be cured by several clever arrangements. Rolleiflex (and others) offered close-up lens sets with a parallax-correcting prismatic upper lens that shifted the view so you were actually looking more or less at what the taking lens did. The spectacular, interchangeable-lens Mamiyaflex had a couple of cute tricks, the simplest of which was a "paramender" that you attached to the tripod (most close-ups are taken on a tripod, after all). The photographer set the exposure, composed and focused the image and then cranked up the paramender, putting the taking lens precisely where the viewing lens was.

IF YOU PLAN ON TAKING SERIOUS CLOSE-UPS, PARALLAX AGAIN BECOMES AN ISSUE...

Wide-Angle. Many photographers who use TLRs would like a wider or longer view than the 75mm or 80mm "standard" lens (that's about a 55° angle of view, or like a 40mm lens on a 35mm camera), so Rollei, Yashica and others sold front lens-element attachments to fix that. Rollei called its auxiliary lenses Mutars. The 0.7 Mutar offers a one-third increase in

angle of view—about the same as a 32mm lens on a 35mm camera. The Tele-Mutar offers 1.5x magnification that is comparable to a 100mm short telephoto on a 35mm camera. Rolleiflex made several thousand 150mm Tele-Rolleiflexes that were used for years in portrait studios. The slightly longer focal length of a "short telephoto" seems to flatten and flatter the features of a human face. Big noses no longer seem so prominent, and you get to work a comfortable distance from the subject, which makes the ordeal of sitting for a portrait a little less menacing for the subject. But we are well ahead of the story here. . .

❦ HISTORY

The history of the twin lens reflex dates back to the earliest carry-along cameras. In some ways, the box Brownies are TLRs in that they do have a little reflex viewer into which one peers down to aim the camera. Some Daguerreotype cameras were twin lens reflexes, and plate cameras from the 1900s could be had as TLR versions, too. (The single lens reflex was also well-known sixty years before that design became popular.) But it remained for the 1920 partnership of Paul Franke (the marketing and sales whiz) and Reinhold Heidecke (the camera designer and manufacturing genius) to refine the TLR concept, popularize it and spawn as many as a hundred imitators.

SOME DAGUERREOTYPE CAMERAS WERE TWIN LENS REFLEXES, AND PLATE CAMERAS FROM THE 1900S COULD BE HAD AS TLR VERSIONS, TOO.

The July 1957 issue of *Popular Photography* (the annual "special 2¼" x 2¼" issue") listed more than thirty TLRs on the American market selling for prices ranging from $30 or so to well over $300. (And that was when the TLR was already falling from grace!) In 1957 you could buy the new Rollei E with an f2.8 lens and a built-in selenium meter for $335, the new Leica

M3 rangefinder (with an Elmar f3.5 lens) for $363, or SLR 35mm cameras like the Practika, the Nikon F, Alpa and Contaflex or even the relatively new Hasselblad for $379! Which would you choose in 1957?

Many were looking to the Hasselblad SLR, which used the same fast f2.8 Zeiss Planar lens as the Rollei TLR. It had a focal-plane shutter that hit ¹/₁₀₀₀ of a sec-

My favorite TLR, the Rollei F with a 35mm Schneider Xenotar lens, with which most of the photos in this chapter were taken.

ond, while the Rollei's leaf shutter only topped at $^1/_{500}$. The "Hassy's" through-the-lens viewing system not only showed you what the actual taking lens saw, without separate close-up doo-dads, but offered interchangeable lenses, too. It also had interchangeable backs that could be loaded in advance, making the Hassy the darling of fashion photographers. In the late 1960s Rolleiflex also began making a single lens reflex that also produces 6cm x 6cm negatives.

IN THE LATE 1960S ROLLEIFLEX ALSO BEGAN MAKING A SINGLE LENS REFLEX. . .

Still, from 1930 to 1960, the Rollei TLR was king in a lot of ways. First, it was (and is) relatively light for a

The Rolleiflex TLR is famous for its lenses, which are known for their fine rendering of texture. This is a "machine print" from a photo lab.

roll film camera that offers so large an image. After 1934, when the lever advance was incorporated together with the "automatic" frame counter, the Rollei Automat also became an easy-to-load, easy-to-use, and fast-to-focus press camera. From the first, Rolleiflexes could also be synchronized for flash.

TO MAKE THEIR PRODUCT MORE AFFORDABLE DURING THE DEPRESSION, F&H PUT OUT THE ROLLEICORD.

To make their product more afford-able during the Depression, F&H put out the Rolleicord. This had a knob advance, still required the paper-backed film to be advanced past a certain point before closing the back (to make the counter work), and had a somewhat less expensive lens (a Zeiss Triotar instead of a Zeiss Tessar).

The Rollei TLR is such a cult camera (until very recently they were still hand-assembled in Germany and can still be bought brand new at this writing for $3,800) that there is all sorts of material out about their history.

❦ FUNCTION

My dad had a Rolleicord for years, and when I went to college I swapped my Crown Graphic press camera to a student newspaper photographer for an old Rolleiflex Automat that had seen better days. Nonetheless, I could get the film from that camera developed and printed at the drugstore—something I could not do with a 4" x 5" press camera. Additionally, the 2¼" contact prints were big enough to see the details.

I used it until I switched to color slide film and 35mm rangefinders in the mid-1960s. Yet, I have come back to Rolleis and owned a dozen or so in the last three years. My favorite one is an F model made around 1962. As often as not, one of the Rolleis is with me when I leave the house.

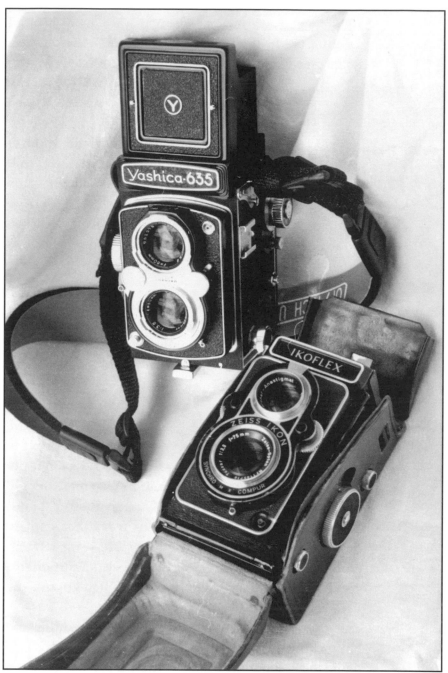

Two Rolleiflex competitors, the Zeiss Ikoflex (which used the same Tessar lens as the earliest Rolleis) and the Yashica 635—a TLR that came with an adapter to use 35mm film. This image was taken with an another Zeiss Ikoflex.

❦ OTHER TLRs

I am not a TLR snob, and you should not be one either. A good used Rolleiflex will cost between $400 and $600 dollars (at this writing), whereas a mint-condition Yashicamat 124G will be around $200 to $250. A Minolta Autocord will be a bit less than that, and a top-grade, late-model Rolleicord (which had a Xenar, Xenotar, or Tessar lens) should not cost more than $300. I'd look for the last models made, such as the Rolleicord IV or V series. In fact, with any classic made over a period of time, it is best to seek out the latest ones if you plan to use them much. However, these brands are just the tip of the TLR iceberg.

WITH ANY CLASSIC MADE OVER A PERIOD OF TIME, IT IS BEST TO SEEK OUT THE LATEST ONES IF YOU PLAN TO USE THEM MUCH.

European TLRs. Germany produced the Zeiss Ikoflex (in several permutations), the basic Voigtlander Brilliant and (upscale) Superb, as well as several lesser brands (including the amazing bellows-fitted Zecaflex that folded flat for carrying). Britain offered the Microcord and France the Semflex, while other makes of TLR came from Czechoslovakia, Russia and East Germany.

Japanese TLRs. Japan produced such marvels as the Ricohflex, Kalloflex and professional (interchangeable lens) Mamiyaflex, the Walz and Tower "flexes" and the fine Yashica and Minolta models.

American TLRs. In the United States, we had the Kodak Reflex, the Ciroflex (later called the Graphic Reflex) and the Ansco Automatic Reflex. The Kodak TLRs are fine cameras, but they all take 620 film, which is an obsolete size. With every part made in the United States, the Ansco Automatic is a handsome blend of art deco design and sturdy American engineering, apparently machined from a solid block of steel. It featured an 85mm Wollensak lens, a Rapax shutter with speeds to $1/400$ of a second, and a crank

film advance. These cameras can be found for around $200 today. The Graphic or Ciroflex TLRs (these are identical—Ciro made them, then was bought out by Graphic) have the same similar optics and shutters, however, and are often found for less than $50. They are equally rewarding to use, although all have fairly dim viewing screens that often need to have the dust blown out of them.

New, "Bargain" TLRs. Contemporary "bargain" TLRs such as the Seagull from China and the Russian Lubitel can often be found new for around $100, but I'd suggest picking up a used Rolleicord, Yashica or Minolta for just slightly more, if you are interested in experimenting with this type of camera.

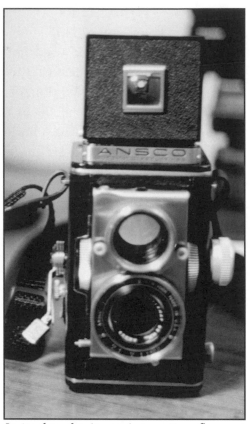

In its day, the Ansco Automatic reflex cost more than a Rolleiflex. This American-made camera was apparently carved from a solid block of aluminum.

❦ INTERCHANGEABILITY

If you want to find filters, sunshades and other accessories for your TLR, you'd be wise to stick to the early Rolleiflex Automats, Rolleicords, Yashica and Minolta TLRs. All of these cameras use what are called "Bay 1" (for "bayonet") accessories. Thus, a Yashica sunshade will fit on a Rollei, and a Minolta lens cap, a Vivitar accessory telephoto lens set or a Rollei Bay 1 close-up set are all equally interchangeable among all three brands. The later Rolleiflexes (the E and F models)

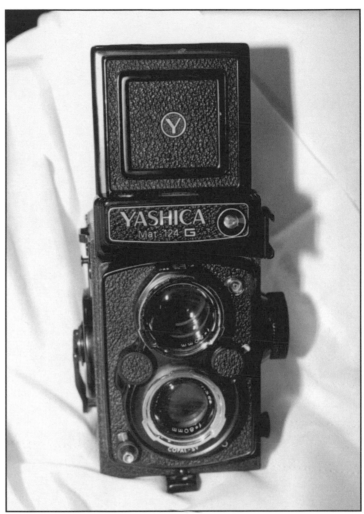

Yet another Yashica, the 124 G with CdS meter. A perennial favorite of photography majors, these can be found in pristine condition for around $200 in 2001.

take Bay II accessories, and the F2.8 Rolleiflexes use Bay III filters. For some reason, accessories for the Bay II cameras—my favorites—seem the hardest to find today, so I buy them whenever I come across them.

❧ BEFORE BUYING

The twin lens reflex seems to have been invented in the 1880s, and while the design evolved over the

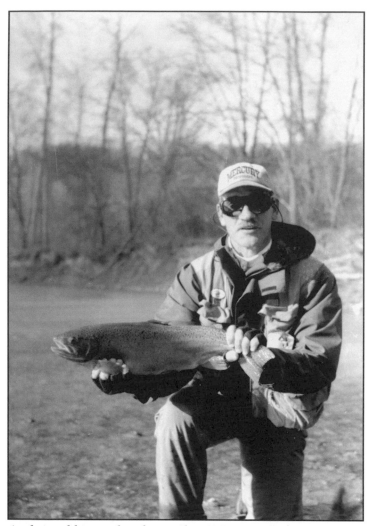

Angler and his catch, taken with a 1950 Zeiss Ikoflex.

years, the basic configuration of the Franke & Heidecke Rolleiflex has remained unchanged since 1920: a sturdy box holds the film and the winding mechanism, while a second sliding box, moved by a gear train, holds and focuses the upper (viewing lens) and the lower (taking) lens simultaneously.

Focusing. If focusing seems unnaturally stiff, chances are good that the camera has been dropped and the mechanism is out of alignment. Look for another sample.

Shutter. The only other serious problem with many TLRs is a sluggish shutter. Often, this can be "cured" by simply watching a half-hour of television and clicking away until the lubricant loosens up. However, if the slow speeds continue to be way off, the camera will need a cleaning—a fairly easy job and well worth the money spent if the rest of the camera is acceptable. Rolleis tend to be almost bulletproof, however, and the Japanese shutters of the 1950s and '60s seem equally tough.

ROLLEIS TEND TO BE ALMOST BULLETPROOF HOWEVER, AND THE JAPANESE SHUTTERS OF THE 1950S AND '60S SEEM EQUALLY TOUGH.

Light Leaks. The box that holds the film has a lighttight lower body, and I've never seen one that was bad in this respect.

Mirror. The body also houses a mirror that reflects the image seen by the viewing lens onto a ground glass. This upper chamber sometimes gets dirty and dusty and can be cleaned with care. However, if the mirror silvering is gone, look for another sample.

Finders and Prisms. Lenses reverse images, showing them upside-down to the film. The mirror in a TLR cures this problem, but it still reverses the image left to right, making it difficult to look down as you swing to follow fast-moving action, like sports. However, even the earliest TLRs offered either a wire frame sports finder, or collapsed the front portion of the hood to create a straight-through metal-frame viewfinder. You set your focus on the racetrack with the ground glass, then looked through the finder to track the runners as they whizzed past. On later Rolleis with detachable hoods, you can attach a Porro prism that not only allows you to focus and view through the ground glass but also track the action right-side-up and un-reversed—just like the guy with the Nikon F standing next to you!

These photos were taken with a Yashica. Though shown here in black & white, the Yashikor lens produces particularly "snappy" images when used with color films.

Flash. If you like to use flash, the later Rolleis and their rivals have another feature: all shutter speeds are synchronized for electronic flash, so you can use fill flash outdoors so long as you know the rules of compensating and balancing daylight with flash. Of course, for just under $4000 you can buy a new Rollei GLX, which has the same f2.8 Zeiss Planar lens as the Rolleis of the 1970s, but has been upgraded with a through-the-lens coupled exposure meter and a TTL automated flash. That way, you can have the enjoyment of a true classic coupled with the undeniable modern delights of accurate exposure and almost fool-

proof flash when that is needed, either to light a dim cavern or lighten up an otherwise objectionable shadow on a face.

❦ TLRs at Work

Nolan Woodbury, a Coolidge, Arizona photographer, has two passions in life: motorcycles (especially the Italian Moto Guzzi) and old twin lens reflex cameras. You won't know about his second hobby when you see the photos and articles he sells to publications devoted to classic motorbikes because, while the photographer may get credit and a modest check, the camera is never mentioned. A few of Nolan's images follow (pay close attention to the captions!).

Here is Woodbury's personal 1981 LeMans model, completely rebuilt after a crash required massive repairs. He took the shot on Ektachrome 100 with one of his favorite cameras, a Yashica A that sold for less than $50 when new in the 1950s. "I am surprised such a good image can come from a 'cheap' triplet lens," he says. (© Nolan Woodbury)

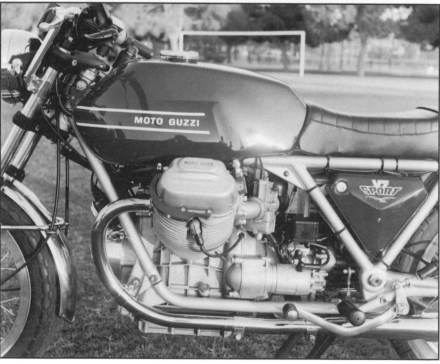

Opposite, Top—This came from a "MotoRetro" meet, a heavily chromed Guzzi shot with a postwar Rolleiflex Automat at dusk, using Ektachrome 100 film. (© Nolan Woodbury)

Opposite, Bottom—This machine was captured, "[W]ith a Rolleiflex MX-EVS that was in such poor condition the seller apologized for taking my money," Woodbury reports. "The Schneider Xenar lens is so badly scarred it is almost impossible to see through it, yet the images it produces are useful, if not spectacular." A yellowing of the print seems to be characteristic of this lens, Woodbury says. I suspect the scratches have the same effect as using a soft-focus attachment. One thing Woodbury insists on is using a lens shade on almost all cameras. This may help a scratched lens, since less stray light can bounce off the many surface scratches to wash out or flare the image. (© Nolan Woodbury)

Below—The yellow bike is a preproduction 1992 Moto Guzzi Sport that Nolan shot at a national rally for the marque in West Virginia using a Minolta Autocord (skylight filter lens hood) on Ektachrome 100.

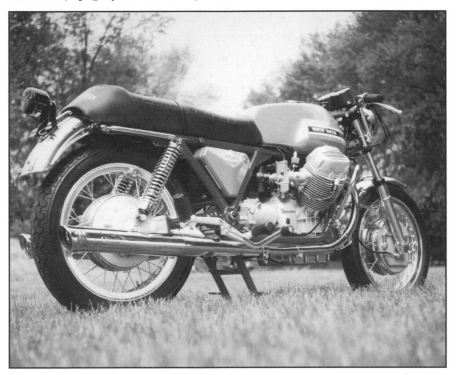

As it turns out, one side benefit of TLRs is that they allow one to compose motorcycle photos without having to kneel down!

14.
TLR (and Other) Accessories

*T*HE TWIN LENS REFLEX CAMERA spawned loads of accessories, probably because Franke & Heidecke realized early on that the camera had some inherent shortcomings for all-around work. I've already mentioned the sports finders and three close-up sets that allow one to work as close as 9" without serious parallax problems, but that is only the beginning of the accessory list!

☙ CARRYING CASES AND STRAPS

The first accessory, and the one most often found, is an ever-ready case. Of course, many of us who use our cameras a lot call them "never-ready" because they have to be opened to get to the controls and expose the lens and make reloading film a pain in the neck. Moreover, some models have front panels that continually fall off when unsnapped. Yes, they will protect the camera, but I prefer keeping my TLRs in plastic storage bags at home and using a handy, foam-lined camera bag that I customize for whatever camera (or cameras) I am going to carry.

SOME MODELS HAVE FRONT PANELS THAT CONTINUALLY FALL OFF WHEN UNSNAPPED.

A neck strap is indispensable. While most classics—especially Rolleis—had thin, leather or even

neck-cutting chrome "snake-chain" straps, I prefer a wide, modern foam/lycra strap. These really do help reduce the load on your neck or shoulder.

❦ FILTERS

Filters are a big help, especially if you shoot black & white film. A yellow filter will bring out clouds and helps define bright whites. Beach scenes, scenes with dramatically cloudy skies, or photos of sailboats are just some examples where this filter will help define whites. Orange filters are also nice to help shift the apparent tonality in a black & white negative, which they do more dramatically than light or even medium yellow filters. Dark red filters can really darken a sky and shift flesh tones. Polarizing filters may be better yet. They cut glare, darken blue skies (in color shots) and generally increase color contrast as well as contrast in black & white images. They also help when photographs are being taken through shop, café, plane and train windows.

Lens shade, a variety of Rolleiflex filters and a flash unit for a Rolleiflex.

Blue filters can be used to take color pictures inside (under incandescent light, not fluorescent!) using outdoor color film. This was a popular trick years ago, but I don't know anyone who does it now—especially since electronic flash is balanced for daylight and the modern eye does not mind the ruddy tones of daylight film exposed indoors under lamp-

light. But my favorites (on the Rolleiflex) are the lenses sometimes called "dutos" or Rolleisoft. These have almost invisible concentric rings inscribed on them that soften the image, especially wide open. The #0 Rolleisoft is meant to be used wide open for portraits (it helps banish wrinkles!), while the #1 can be used stopped down to f5.6 or so and still get that effect. They are also useful in cutting glare in backlit pictures.

Three popular accessories—a pistol grip, a flash bracket and an electronic flash.

When you screw on any filter, you should pay attention to the exposure compensation number engraved on the rim. Some (such as skylight filters or soft-focus filters) do not absorb light, but the colored filters all do, so you'll have to add anywhere from ½ to three stops of exposure when using a filter.

❦ SPECIALTY LENS SETS

"Mutars" were the next development Rollei offered. These are lens sets that would either increase the focal length by 50% to make the prime lens into a portrait or short telephoto, or decrease the prime lens by 30% to make it into a mild wide-angle. They were popular with some photographers but are relatively rare (and expensive) on the used market. TLRs also have close-up sets that allow one to shoot as near to a subject as 9".

The Rolleiflex Automat, made from 1938 to 1950, used a small bayonet fitting now called "Bay 1"— because later Rolleis had larger bayonet fittings. Yashica and Minolta TLRs use the same size bayonet,

so their accessories will fit on a Rolleiflex and vice-versa. Vivitar, Walz and other aftermarket Japanese providers made Bay 1 auxiliary lenses, particularly close-up sets and tele-wide lens sets. These aftermarket lens additions might be more easily found today than the brand-name sets, and would be equally interchangeable between these three most commonly used classic TLRs.

🐦 Lens Shades

Most important, especially on older classic cameras is the need for lens shades. Because these lenses either had no lens coating or had anti-flare coatings inferior to today's coatings, a lens shade is really worthwhile.

That's true for any kind of classic camera. With care, you can keep lenses from becoming dirty, smudged or scratched, so a protective ultraviolet or skylight filter is not really necessary—and can add to flare as it intrudes as another glass surface. But, if you want to shoot backlit subjects at all, a lens shade imperative.

15.
Press and View Cameras

*T*HE ONE CLASSIC TYPE THAT HAS REMAINED almost frozen in time throughout the entire history of photography is the plate camera. Today, of course, they use cut sheets of film instead of metal or glass plates, but these really are not much different from the Daguerrian and wet-plate cameras used to document the Civil War.

Still, there are differences between what is called a "press" (or sometimes "field" camera) and a "view" camera. Both consist of a body to which is attached some sort of back that allows the user to focus through a ground glass, insert a film holder, close and cock the shutter, pull out a dark slide and expose the image. Both types have extendible bellows made of leather, rubber or some other material that folds down to make a compact "box," usually fitted with a handle for easy carrying.

THERE ARE DIFFERENCES BETWEEN WHAT IS CALLED A "PRESS" (OR SOMETIMES "FIELD" CAMERA) AND A "VIEW" CAMERA.

🎞 PRESS CAMERAS
The press camera is the easiest to find and the cheapest to buy, since so many of them were used for so long. Despite their rugged service, they can be easily repaired, often by an amateur with a handful of tools.

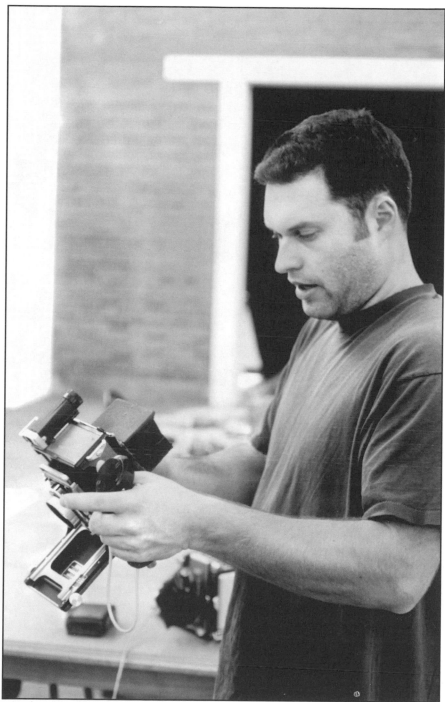

The famous "Baby" Speed Graphic press camera has a ground glass back for precise focusing. A popular accessory is a roll film back that slips in front of the ground glass to create 6cm x 9cm photos on 120 film.

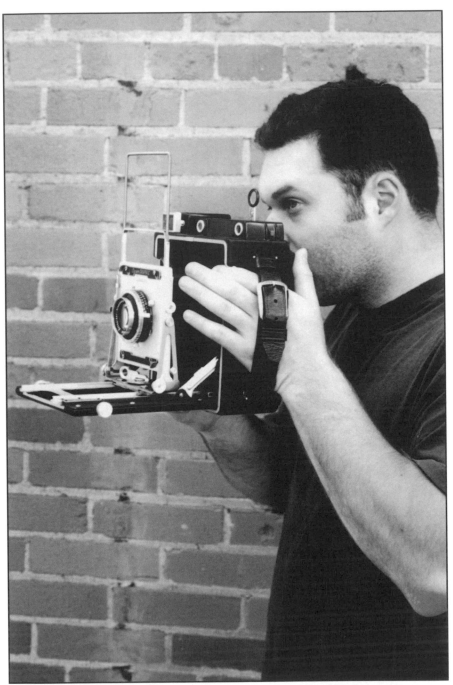

The famous Speed Graphic was a workhorse press camera for a half century and is still a usable instrument. Here is a 4" x 5" model set up for spirits using a wire frame finder. A rangefinder is on top, and the camera has limited movements to allow for some compensation when tilted up or down.

Typical is the Speed Graphic. This had two shutters: a lens-mounted shutter that usually offered speeds from one to $1/400$ of a second, and a focal-plane shutter that went up to $1/1000$ of a second. The Crown Graphic was the same camera, minus the focal-plane shutter. One feature both shared was a lens board that could be removed and replaced with a board carrying a wide-angle or telephoto lens. Other makes, such as Busch, Horseman, Makina, Goerz and Butcher (to name a few) were made in every camera-making country, alongside the same companies' huge single lens reflexes mentioned in the SLR chapter.

Press cameras usually have wire frame sports finders, and many have coupled rangefinders, too. They are focused by racking the bellows in and out. One can scale focus, rely on the split-image rangefinder, or use the ground glass to obtain a sharp image. The film holder is then slipped in a spring back. The film itself will be in the same place as the ground glass was.

In the mid-1950s, I used 4" x 5" Crown Graphic as a "news" camera, carrying a few film holders (two shots—one on each side) in my sports jacket pockets. You got your shot with the first try! With such large negatives, we could use Dektol, the same developer used on paper prints, to blast an image from a sheet of Super XX in less than two minutes, print it wet and have it to the plate-maker. The whole operation took fifteen minutes tops—crucial for making deadlines. (Today, sports photographers use digital cameras and transmit the pictures from the ball game to the newspaper over telephone wires while the event is in progress.)

THE OPERATION TOOK FIFTEEN MINUTES TOPS—CRUCIAL FOR MAKING DEADLINES.

❦ FIELD CAMERAS

Field cameras are a lot like the Crown Graphic in operation but usually without a rangefinder or frame

Here is a studio view camera, twisted so that a tabletop setup can be photographed with no distortion.

finder. The photographer uses a black focusing cloth and works with an upside-down, reversed image—a real help in making one think graphically and seek strong compositions. That's why these cameras are used primarily for nature photography and portraiture (in conjunction with a tripod).

Additionally, where handheld press cameras typically come in 2¼" x 3¼", 3¼" x 4¼" and 4" x 5" sizes, field cameras also come in 5" x 7", 8" x 10", 11" x 14" and almost any other size you can imagine. As mentioned elsewhere in this book, unless you are a millionaire, stick to the 4" x 5" size. It is huge for anyone used to working in 35mm or medium formats, and 4" x 5" contact prints can be successfully exhibited. Of course, the entire negative or portions of it can be enlarged, too, and the resulting images should be far less subject to the problems of grain than anything made with smaller negatives.

❧ VIEW CAMERAS

The view camera is even more sophisticated. Whereas the press camera or field camera may have a rising front or a dropping bed to allow for some image manipulation, the view camera can be contorted in virtually any direction to keep the film plane parallel with the subject. Why? Because the minute you tilt the film out of parallel with the subject, you introduce distortion. You've seen the tall building that vanishes to a pinhead? Well, with a proper view camera (and the right focal length lens), you can take architectural photos that show the building's height without the converging lines. That's just one example. Close-up product and food photography is usually done with these cameras, too. For scenery I need only say two words: Ansel Adams. Adams typically used a camera that

THE VIEW CAMERA CAN BE CONTORTED IN VIRTUALLY ANY DIRECTION TO KEEP THE FILM PLANE PARALLEL WITH THE SUBJECT.

❂ View Camera History

As "field" cameras became more common, several developments were incorporated into what we now know as the view camera—for example, a rising front and a dropping bed to change the lens position, and backs that could tilt to compensate for any upward or downward pointing of the lens. In 1895, cabinetmaker Frederick Sanderson designed and built what is pretty much the same view camera we use today. The front could rise, fall and tilt on support arms, each independently moveable along a supporting frame bed. The back could likewise be adjusted so that a full range of rise, fall, swing and tilt was possible.

Today's view cameras do the same thing, although many are built on monorail beds that resemble an aluminum pipe with U-shaped supports for the lens and back. All those adjustments allow everything to be kept in perfect plane, perfect focus and perfect perspective adjustment. This is just what you want when preparing advertising photos or doing architectural studies. These are true classic cameras in that they are totally "mechanical" and the photographer must have a wealth of experience to set them up and make the proper exposure.

The only thing modern is that some of these cameras are fitted with high-resolution scanning backs so that the archive is recorded not on film but digitally. This affords photographers the option to further adjust, manipulate, size and retouch images on a computer using Adobe® Photoshop® or similar programs.

exposed 8" x 10" sheets of film to make his poster-sized enlargements possible—to say nothing of the ability to capture El Capitan in its natural perspective.

Classic view cameras can be mighty pricey, simply because they were not, and are not, mass-produced. A contemporary Toyo, Calumet or Zone VI is just as much a classic cult camera as the vaunted Deardorff (which might cost about the same, given similar optics). For a while, I thought that getting a 2¼" x 3¼" Crown or Speed Graphic with a roll film back would be a good idea, mainly because 120 film costs less than sheet film. After seeing some lovely 4" x 5" contact prints at a local art show, though, I've changed my mind. The young woman who was exhibiting them bought a used Crown Graphic for $100. She arranged

a few stalks of wheat, grass, oats, and things like asparagus in a stucco window sill or placed apples or onions in nice ceramic bowls in good, flat natural light. She made careful exposures, then contact-printed them as they came from the camera. It was an

Another view of a studio view camera.

effective demonstration of what these cameras are best used for today—thoughtful, careful work that is controlled at the moment of exposure, not rescued later in the darkroom.

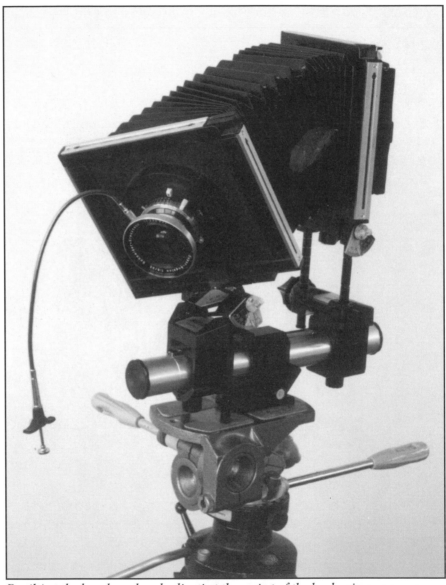

By tilting the lens board and adjusting the swing of the back, view cameras can keep vertical lines vertical (as when looking "up" at a skyscraper) and can compensate for differing distances (as in close-up photography of jewelry for an advertising layout). The huge transparencies they offer are another boon for art photographers.

The ground glass shows the image upside down and reversed (exactly what any camera sees, by the way).

The exposure theory most often practiced by large format camera users is called the Zone System. Since whole books have been written about it, I'll say little except that one must make very educated guesses of every gray tonality in the image from the pure white to the pure black. Ansel Adams would do this, then later work on enlargements as well. Anyone with an eye for composition and the desire to do calm and unhurried work would be well rewarded by some time spent with a large-format press, field or view camera.

16.
Single Lens Reflex

STARTING IN 1960, ONE CAMERA FORMAT became the dominant type for both professional and amateur photographers—the single lens reflex. Like everything else in photography, the SLR has roots dating back to the earliest times—the first SLR patent was granted in 1861!

❦ THROUGH-THE-LENS ACCURACY
Even today, the main virtue of the SLR remains: through-the-lens accuracy. Looking through the camera's only lens means that what you see is what you get. Imagine how useful this is for the macrophotographer of insects or flowers, since there is no parallax to worry about. For the art photographer who wishes to experiment with out-of-focus backgrounds or "soft-focus" filters, stopping down the lens to the taking aperture shows exactly what will be in sharp focus as well as what will blur out. Telephoto users can really be sure the camera is pointed at the right subject and can see how the aperture affects depth of field and the final image. This is important because the longer the telephoto lens, the less inherent depth of field is available at all apertures.

EVEN TODAY, THE MAIN VIRTUE OF THE SLR REMAINS: THROUGH-THE-LENS ACCURACY.

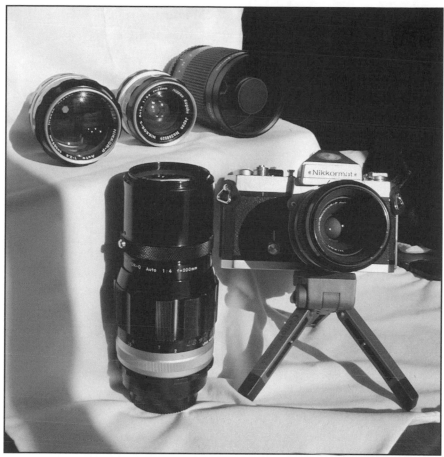

The lens arsenal of the SLR makes it an extremely versatile type of camera.

❧ HISTORY

Until three changes became "universal" in the late 1950s, however, the SLR could never succeed simply because the image blacked out at the moment the shutter was triggered. The first change was the prism viewfinder that altered the image so it was "right side up" and moved properly from left to right. Then came the instant-return mirror, which caused the image in the viewfinder only to "blink" off during exposure and then swiftly return. The final modification was the introduction of "automatic" lenses that allowed one to focus and com-

THE FIRST CHANGE WAS THE PRISM VIEWFINDER THAT ALTERED THE IMAGE SO IT WAS "RIGHT SIDE UP". . .

pose at full aperture. Then, when the shutter release was pressed, the lens stopped down to the taking aperture and blinked wide open again. With those changes, you have a nearly perfect system for every kind of photography in every format—from the tiny 110 cartridge with its thumbnail-sized negatives to roll film behemoths that provide negatives measuring 2¼" x 3¼".

Despite their initial shortcomings, SLRs were popular for certain kinds of work since the early 1900s. Graflex was among the first to popularize the SLR in the United States with its Graflex press and portrait cameras. Essentially, huge boxes with fold-out leather viewing hoods (the images were pretty dim due to slow lenses of f6.8 or so), the Graflex came with an amazing focal-plane shutter that you wound and set. The roller curtains of this shutter featured a slit so that one part of the shutter moved across the film plane, opening the slit to admit light. Then, the second curtain came along and closed it. By adjusting spring tension and the aperture opening, a Graflex user could get a huge variety of oddball speeds (like 1/64 of a second).

DESPITE THEIR INITIAL SHORTCOMINGS, SLRS WERE POPULAR FOR SOME KINDS OF WORK SINCE THE EARLY 1900S.

Since these glass-plate and cut-film giants were closely related to the nineteenth century view camera, different lenses could easily be adapted to these behemoths. When I joined the *Buffalo News* in 1969, they still had "Big Bertha"—a 4" x 5" Graflex with a lens like a howitzer that was used occasionally for shots taken of the field from the press box of the old War Memorial Stadium where the Buffalo Bills then played. This setup had been a baseball photography standby—the telephoto lens could sharply isolate a slugger taking a cut, or a pitcher on the mound while throwing, and kept the background in a nice blur that

focused the viewer's attention on the subject, yet suggested the crowd in the background. Additionally, a 4" x 5" negative could be contact printed to provide incredible detail even with the coarse halftone screens used on newsprint at that time.

By 1969, our staff photographers used one of two cameras: a Koni-Omega roll film rangefinder press camera that produced a 6cm x 7cm negative and took a limited range of interchangeable lenses, or a Nikon F 35mm SLR with amazingly sharp optics and an incredible arsenal of lenses ranging from 180° and 360° fisheyes to super telephotos and even zoom lenses that really made "Big Bertha" seem like a dinosaur.

Zoom Expands SLR Utility. Zoom lenses are what really "sold" the SLR to the pros. A photographer could follow athletes coming toward him and keep the players the size he wanted, or could quickly "crop in the camera" for the composition he preferred. Best of all, after he took the picture, the image snapped right back, thanks to the instant-return mirror, so he did not miss as much potential action. With Big Bertha, the screen went black when the shutter was fired and the mirror did not return until the shutter was rewound. Moreover, Nikon's first SLR, the Nikon F of 1959, was designed to use a motor drive. Thus, one could photograph a diver at the moment of takeoff, follow through the triple twists and capture the moment her hands cleaved the water. You don't see that much anymore, but thirty-five years ago it was a staple on the "picture page" of many newspapers and magazines. (You don't often see those photo pages anymore either, come to think of it.)

ZOOM LENSES ARE WHAT REALLY "SOLD" THE SLR TO THE PROS.

Early SLRs. Others were helping create the SLR too, especially in the 1930s when the development of "miniature" cameras was in its infancy. Dresden's

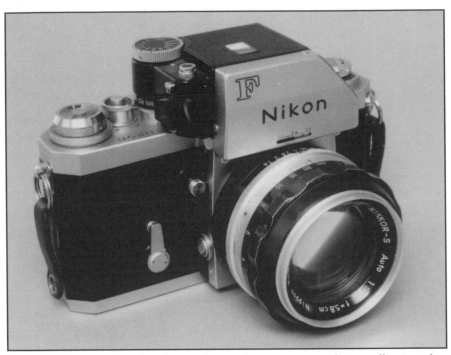

Nikon's first SLR, the Nikon F, was designed to use a motordrive—allowing photographers to capture action as never before.

Exakta is the quintessential SLR, first establishing the shape and control layout that would last until the late 1980s. Originally roll film cameras, these soon evolved into the Kine Exakta (named for the 35mm "movie" film made popular by Leica). These early SLRs had a tiny, waist-level finder with a magnifying lens. I have one of these and am still entranced by the tiny, exact image I see wherever I point the instrument. It is like looking at the world in miniature and, of course, that world goes black when the shutter is released. Still, 35mm film offered brilliant color slides, and film, processing and projectors were a lot cheaper in the smaller format than they were for either the 127 film's "super slides" or the bigger 2¼" x 2¼" images. The price factor alone helped make 35mm slide photography the darling of the 1950s.

Viewfinders. Of course, looking down and focusing so precisely tended to thwart the spontaneity of the

35mm shot, let alone the *Life* magazine photojournalistic approach many of us wanted to emulate. To offset that, there were the lenses (telephotos mainly) that could not be used on a rangefinder camera without a special reflex housing. In fact, 35mm rangefinder cameras are really limited to 135mm telephotos—say 2.5x–3x enlargement. This is partly because focusing accuracy cannot be presumed much above that focal length, and partly due to the limitations of the viewfinders.

With the SLR, of course, the lens itself is the viewfinder, so 1,000mm lenses (20x magnification over a 50mm "normal" optic) are perfectly usable. The prism viewfinder became almost universal after World War II, thanks to Praktiflex, Contax, Pentacon, Rectaflex and others.

Impact of the Korean War. It was not until Pentax introduced the instant-return mirror in 1954 that the SLR really came of age. It was about that time, too, that the Japanese camera industry was fully recognized for the quality and durability it offered. This became an accepted fact because of the amazing service Nikon and Canon rangefinder cameras and lenses gave during the Korean War. Photographers who could not get their Leica and Contax cameras serviced—or broken lenses easily replaced—turned to the Tokyo market where they tried Canon (whose lenses were interchangeable with the Leica thread-mount) and Nikon cameras (which copied the Contax bayonet system) for replacement optics. When they saw that these were as good as, if not better than, their German inspirations—and less expensive!—the rush began. When the Asahiflex (later to become Pentax) came out, offering a pentaprism viewfinder, standard instant return mirror, standard

THE JAPANESE CAMERA INDUSTRY WAS FULLY RECOGNIZED FOR THE QUALITY IT PRODUCED AND THE DURABILITY IT OFFERED.

flash contacts, a usable range of speeds and interchangeable lenses, the demand for Asian products became even more intense. Asahi Optical built their cameras with the then near-standard "Praktika mount" so that scads of optics could easily be adapted. They had a winner. The SLR came of age.

Pentax. By 1957, the same camera (now named "Pentax" for its pentaprism) offered an "automatic" diaphragm that allowed the aperture to be selected even though the lens stayed wide open for easier focusing and viewing until the moment of exposure, when it stopped down to the taking aperture. SLR lenses soon became fully automatic, opening up again without the photographer doing anything. Then came internal light meters that measured through the lens—and the rush

SLR LENSES SOON BECAME FULLY AUTOMATIC, OPENING UP AGAIN WITHOUT THE PHOTOGRAPHER DOING ANYTHING.

In 1964, the center-weighted averaging meter in Pentax's Spotmatic was hard to beat.

to SLR turned into a stampede. Pentax's center-weighted, averaging meter in the "Spotmatic" of 1964 was hard to beat.

Nikon. In 1959, Nikon entered with its SLR—which cost the same as a Leica M3, had interchangeable viewing screens and a viewfinder that showed 100% of what the film saw (you lose about 5% around the edges when you mount the images in slide holders). All in all, it was a camera designed to be a pro's workhorse. Built like a tank, the Nikon F literally thrived on abuse.

In 1970, I bought an eight year-old Nikon Photomic F whose erratic meter was replaced with a standard prism. Together with its f2 50mm, f3.5 135mm, f4.5 300mm and f2.8 28mm lenses, it was my sole camera outfit for years, literally traveling around the world with me. It performed with precision and reliability without a single tune-up. Some twenty-five years later, I sold each bit for the same price I paid when I bought it—and sold the 300mm lens at a profit. Today, having gone back to a Nikon for telephoto and close-up work, I realize the folly of ever selling any camera. Better that your grandchildren should be delighted at some future date by finding and playing with these relics!

SOME 25 YEARS LATER, I SOLD EACH BIT FOR THE SAME PRICE I PAID WHEN I BOUGHT IT. . .

❦ ARE CLASSIC SLRS REALLY ALL THAT CLASSIC?

Are there classic SLRs? If so, what brands or models should one consider for use today?

The first part is easy: if they are mechanical (with or without an electronic light meter) and are landmark cameras, then they are "classics." The fully developed models are quite simply the most versatile type of cameras that can be used, and feature almost the same eye-level ease as a rangefinder. They are also the best kind of camera to use if you want to take

nature photos (long lenses are a *must* here) or do extreme close-up work.

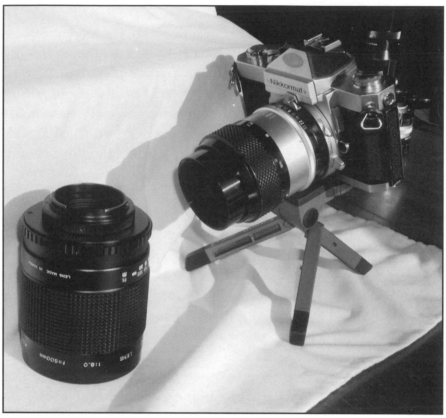

SLRs are the best type of camera to choose for close-up work.

❧ CHOICES

Quality cameras always sell for more than lesser-quality machines. That's true either new or used. At this writing, however, collectors have not skewed the market for 35mm single lens reflexes quite as badly as the Leicaphiles have with their treasured rangefinder cameras. In the medium-format market, prices can still be quite high, especially for Hasselblads, which in some ways epitomize the "larger" SLR ranks today.

Medium Format SLRs. Hasselblad, that Swedish 2¼" roll film SLR, remains a landmark because it was, and is, built to the highest standards. It has a cult following among oral surgeons and similar well-paid pro-

fessionals whose chief hobby is photography. That alone means that prices start high and tend to stay there. Conversely, if you can find a sound, hobbyist-owned Hasselblad, buy it. It will probably have had decent care and likely will last a long, long time. (The same might be said for the Rolleiflex SLRs, which also come with the same marvelous Zeiss and Schneider lenses, or even for Bronica and Mamiya, leading Japanese makers.)

Jim Gavacs, who owns one of the leading portrait and wedding studios in Buffalo, NY has always (or almost always) used roll film cameras in his work. For years, he used tough Mamiya TLRs with their inter-changeable lenses, then switched to Mamiya and Bronica SLRs because they were much more flexible.

FOR ONE THING, ALMOST ALL MEDIUM FORMAT SLRS HAVE INTERCHANGEABLE BACKS. . .

For one thing, almost all medium format SLRs have interchangeable backs, which means one can keep shooting by simply switching backs. Moreover, color and black & white can be accommodated on the same job with the same setup. With some of these cameras, one can switch formats as well, shooting anything from 4.5cm x 6cm images up to 6cm x 7cm or 6cm x 9cm using the same modular system.

Not Hasselblad and Rollei, though—they stick to the "perfect" square of 6cm x 6cm that can easily be cropped for a vertical or horizontal later. This means you don't have to stand the camera on end to get the vertical shots. Being SLRs, they have through-the-lens viewing, and Jim can choose whatever lens he needs, from a wide-angle for a tight shot of the bride getting ready in a cluttered dressing room, to a telephoto for the ceremony taken from the back of the church.

"Five years ago, I changed to Hasselblads," he told me. "They are more expensive, but they hold up and the lenses are superior." He means the later versions,

with shutters built into each lens. The earliest Hasselblads (with focal-plane shutters) seem to be trouble-prone. Besides, for a working pro, the ability to synchronize flash at all shutter speeds is another plus, and the Compur-shuttered lenses allow that.

35mm SLRs. My own experience is with 35mm SLRs, admittedly the near universal choice of serious photographers for the last thirty years. Of those, I would single out five brands that I think are the least troublesome "classics," in part because they were popular for so long (thus parts and repairmen are thick on the ground) and because they work. They are: Canon, Minolta, Nikon, Olympus and Pentax.

Nikons are my personal choice because I know them best. The controls work well for me. The old models (where each lens has to be installed so a little meter pin hooks into the U-shaped fitting on the lens, and then the lens aperture has to be racked from full open to full closed to set the meter) are my first choice. To save some money, look at a Nikkormat FTn or FT2 first. These sold more to amateurs than to pros, although many pros carried Nikkormats as a backup. Nikkormats seem to be more easily found (and in better shape) than the F models of the same age. The meters seem to work, too, and lenses can be a bargain. Buy older "non-AI" (automatic indexing) lenses. You'll have to do the twist and shout drill of lining up the pin on the camera, grasping the aperture ring and twisting to full and minimum aperture to set the meter for each lens, but you can save a great deal of money and get a full range of incredibly sharp optics—anything from an 8mm fisheye to a 1,000mm super telephoto. (Automatic indexing lenses with electronic contacts, and fully autofocusing lenses are also available, but these are *not* classics.)

To save some money, look at a Nikkormat FTn first.

Nikon F bodies are nicer, in that they have detachable prisms so you have all sorts of options for looking into them. They also feature interchangeable viewing grids and a somewhat better shutter than their lesser brothers. Still, the cameras are basically the same,

except that Nikkormat backs are hinged and the old Nikon F back drops off (like the Contax rangefinder that spawned its initial design).

In 1999, I purchased a very nice Nikkormat FTn with an f2 50mm lens for $100. I spent $65 more for an f3.5 55mm macro lens (this rig was used to take many of the camera photos in this book). I added an f2.5 105mm portrait lens for another $100 (a lens I could not afford when it was new), spent $65 more for an f2 35mm wide-angle, and another $85 for an f4 200mm telephoto—all of which fit into one small bag. Do the math: this entire outfit set me back $415. That's the price of a modern low-end SLR with a 35mm–70mm

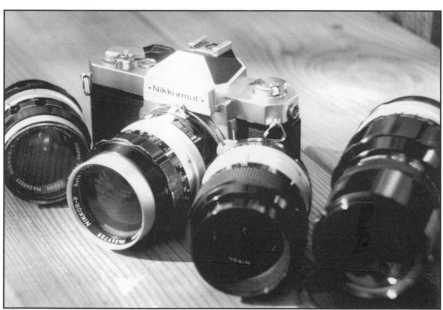

The author's Nikkormat outfit with 35mm, 55mm macro, 105mm portrait and 200mm telephoto lenses.

zoom lens. It's about a quarter of what I'd have to pay for a contemporary low-end Nikon outfit with the same range of focal length capability.

I might have spent even less for a Canon, Pentax Spotmatic, Minolta SRT or Olympus OM1 outfit. (I'd have a little more room in the bag and tote a bit less weight, too, since those cameras are smaller and a bit lighter.) Minolta and Pentax gear simply does not command the prices that Nikon or the Canon F1 systems do. While the Canon F1 is a rival in flexibility, cost and quality to the Nikon F, old "professional" Canon bodies did switch lens mounts occasionally. To this day, old Nikon SLR lenses will work on any Nikon SLR body, although they have to be set by hand and won't meter through the modern electronic bodies. Conversely, the new autofocus lenses and even some of the last manual ones don't have the fitting to hook up mechanically to the old camera's meter systems.

I MIGHT HAVE SPENT EVEN LESS FOR A CANON, PENTAX SPOTMATIC OR MINOLTA SRT OUTFIT.

The best "bargain"—a camera inherited from a relative! The Minolta SLR is flanked by a pair of zoom lenses, a 24mm–40mm and a 70mm–200mm.

Olympus revolutionized things for a while with its OM series, cameras that were almost as compact as many rangefinders and possessed of a wide variety of very, very good optics. But, in my limited experience, the bodies are a bit fragile (my Olympus OM1 broke after two years). Hence, I never became a fan—although I did like their (comparatively) diminutive size and the quality of image obtained from their lenses (the 105mm lens in particular).

Cult Cameras. In the world of "classics" there are always going to be some cult cameras that were and remain out of the mainstream. Zeiss, particularly, has its fanatic adherents. Some examples follow.

The "Bullseye" Contarex from Zeiss Ikon continues to be a top-dollar seller. Even the humbler Contaflex, a between-the-lens shuttered SLR (the Kodak Retina reflex is another designed like that) has its fans. I'm not among them. Both of these cameras tend to be complex because the shutter has to be open for focusing and composing (the reflex mirror or a blind closes off the film chamber). Then, when you push the shutter release, the shutter closes, the mirror swings up and the shutter fires, then closes again. I suspect this complexity may make the shutter mechanisms a bit fragile and it does limit the choice of telephoto and wide-angle lenses. Contaflexes have superb optics but all models have viewfinders that black out after the exposure is taken. While this is not the world's most serious drawback, I happen to hate SLRs that do not have instant return mirrors and need to be rewound to see again. (I told you this would be an opinionated book!)

If you want to experiment with a 35mm SLR relatively cheaply look for Exaktas (the early ones also had non-returning mirrors) and Exas—the later the better. They are relatively cheap and countless lenses

THE "BULLSEYE" CONTAREX FROM ZEISS IKON CONTINUES TO BE A TOP-DOLLAR SELLER.

are out there (with optics ranging from bad to superb). This, combined with the availability of numerous accessories, has created a large following for these cameras. In fact, Pentax used the Exakta mount for many years.

If I ever won the lottery, I would be tempted to amass an Alpa reflex system. Alpa, a Swiss camera maker, was the first to offer a "macro" lens as its standard optic—the Kern f1.8 Macro-Switar. Alpa was designed from the start to be a scientist's "system" camera that offered all sorts of neat angled viewfinders and a terrific range of lenses. Alpas had a film advance in front of the body—you pulled on it like a trigger to advance the film and cock the shutter, and then used the aperture ring to meter by stopping-down the lens. The last Alpas had wide-open light metering. The lenses

IF I EVER WIN THE LOTTERY, I WOULD BE TEMPTED TO AMASS AN ALPA REFLEX SYSTEM.

were excellent and came from all over the world. Although Kern (Switzerland) and Angenieux (France) are not household names today, before and immediately after WW II they were among the very best. The last time I looked, a fairly modern Alpa (a 9 or 10 series) sold for around $2,000—four times what it cost new in the late 1950s.

Yet another classic SLR is the Leicaflex. For details on these (as well as all other SLRs mentioned in this book), I'll refer you to Ivor Matanle's *Collecting and Using Classic SLRs* (see page 179.) I'll say this: Since anything marked "Leica" costs more than anything made by any contemporary (except Alpa), I'd just as soon sink my money into an all-mechanical modern Leicaflex and be assured I could find lenses as my budget permitted. For, unlike the M-series rangefinders, Leicaflexes have two-cam, three-cam and 3-cam "R" models. If you get a Leicaflex or a Leicaflex SL, you will have a limited selection of optics.

17.
Exposure Basics

E'VE ALL COME TO BELIEVE that ultra-accurate exposure is the major criterion for a good photograph. This is not true now, and it was never true in the past, either. In the early days of photography, plenty of folks got perfectly adequate photos with box cameras. The vast numbers of wonderfully captured memories that are taken with today's "disposable," or single-use cameras, prove the point that focus, f-stop and shutter speeds are all a bit relative. For one thing, the early cut film and roll film users either had darkrooms or used commercial houses that had darkroom technicians who checked film development by inspection. All printing was surely done by inspection, too.

IN THE EARLY DAYS OF PHOTOGRAPHY, PLENTY OF FOLKS GOT PERFECTLY ADEQUATE PHOTOS WITH BOX CAMERAS.

Then, as today, if the film is overexposed, it needs to spend less time in the developer. If it seems to be underexposed, it needs extra seconds in the tank. Underexposed negatives are "thin," so a shorter burst of light from the contact printer or enlarger is used when making the print. If need be, the resulting prints, if overexposed, can get curtailed development, too—although this leads to a relatively flat, low-contrast image. An overexposed negative can get longer exposure ("burning in"). It, too, can be given less time

in the developer. In your own darkroom, you can make a print more contrasty or more evenly-toned gray. (This was one objective of good newspaper photographs in the classic era, because high-contrast halftone printing plates tended to block up quickly on porous newsprint.)

Today, our films are immensely more flexible, allowing up to two stops latitude for over- or underexposure. Because of this, a totally accurate meter may not be as important as it was, say, in 1955.

❦ "Dead" Meters

Most meters in the classic era used a light-sensitive selenium cell to create a small electrical charge that could be measured (the more light, the more juice, the more the meter needle swings). These tend to "die" with age. As a result, a lot of super cameras—like the Zeiss Ikon Contessa or Kodak Retinas—had built-in selenium cell meters that are dead as doornails today and might not be repairable. If they are repairable, the cost normally exceeds that of a new, handheld selenium-cell meter or even a modern meter with a silicon or cadmium photocell. These later meters need a battery linked to the light-sensitive cell; they are virtually indestructible and very accurate.

A LOT OF SUPER CAMERAS HAD BUILT-IN SELENIUM CELL METERS THAT ARE DEAD AS DOORNAILS TODAY. . .

In some cases, the classic meters use the now "illegal" (hence, obsolete) mercury batteries that may not have a safer counterpart today. The result? Another "dead" meter.

Handheld meters can be more accurate than in-camera meters and, of course, can be used from camera to camera. The easiest to use are reflected light meters: just point them at the subject and take a reading. Incident light meters are better for studio work: hold them in front of the subject, point them at the

The Selenium cell meters on the left include an inexpensive contemporary meter and a classic Sekonic. The two Gossen CdS meters have incident light domes as well as reflective-light capability. They do require batteries, however.

light source, and they measure the light falling on the subject.

❦ To Meter or Not To Meter

Sometimes meters get in the way of art and certainly of reportage. Jim Hughes, one of the great gray eminences of photography who writes in *CamerArts* magazine (and who wrote a spectacular biography of photojournalist W. Eugene Smith), says: "I don't want even a meter needle in my viewfinder. It is a distraction to seeing." Besides, he notes, "We [photographers] are really trying to see light, get a feel for it, and

you can only do that by experimentation with an emulsion. If you know what your film will do, after a while you can select the exposure to capture exactly what you want to express."

Light meters are invaluable if you are photographing somewhere outside your experience, though. In the tropics, for example, the light "looks" the same, but because you are closer to the sun at the equator, the light really is much brighter. Your eyes have merely adjusted to the increased intensity.

❧ METERING BASICS

All meters are designed to provide an accurate reading for 18% gray (about the same reflectivity as the palm of a Caucasian hand). Therefore, the "correct" (indicated) reading for a solid white wall will actually render the wall 18% gray on the film. To compensate for this, you must open up a bit (increase exposure) for subjects like snow or beaches, if you want the snow/sand to register as a white (rather than gray) surface. If you are shooting a high-contrast situation and meter on a light area, the shadows go black. If you meter on the shadows, the light areas get burned out.

ALL METERS ARE DESIGNED TO PROVIDE AN ACCURATE READING FOR 18% GRAY.

Meterless Exposure. This does get confusing—fortunately, you don't really even need a meter for most photography. Some film boxes still print an exposure guide (for the temperate zones) inside. Rip the box open and you'll see instructions for setting the camera for bright sunlight, open shade, deep shadows, and so forth. I often tape one of these guides to the back of a camera if I want to save the weight and bulk of a meter.

Another handy exposure guide is the "sunny 16 rule." Simply select the shutter speed nearest the film

Stick this in your pocket or carrying case, set your shutter to the speed nearest the film speed (here, $^1/_{125}$ of a second) and the pictorial guide suggests which f-stop to use. These guides are usually printed inside consumer-grade film boxes.

speed ($^1/_{200}$ of a second for 200-speed film, $^1/_{500}$ of a second for 400-speed film, etc.), then set the lens on f16. That will give you a decent exposure for an average scene in bright sunlight. Then open up (or slow the shutter speed) for overcast light, open shade, deep shade, indoors, a lit stage, etc. This works especially well with black & white and color negative films. In the winter, spring and fall, you may want to use f11 for "sunny" and then work from there.

☙ FILM SELECTION

Film can be to a photographer what paint is to an artist. That is, different film emulsions "see" light differently, hence they can help shape your palette.

Black & White. For those readers who have even very little experience with black & white film, it will

be obvious that it reacts differently to colorful scenes than color film does. Using black & white one works only with shadow, highlight, contrast, shape, and form. The rule is to expose for the darkest part of the picture in which you want to see detail.

In black & white films, I have for years used ISO 400 films, mostly Tri-X. Most of my black & white shooting these days is with chromogenic emulsions like Kodak T-Max CN, Kodak Select B&W or Ilford XP2-Plus. These are color print films that have no dyes. They are run through a one-hour lab using the same C-41 color chemicals and the same color print paper you'd use with Fuji or Kodacolor negatives. With these, you can have the film developed and printed at any drugstore with an auto-mated color lab. I usually spring for the full package and get 4" x 6" prints made too. Sometimes (especially with 120 roll film, which my favorite minilab cannot print), I just have the film developed and make my own prints later.

MODERN COLOR FILMS HAVE GOOD COLOR LATITUDE AS WELL AS EXPOSURE LATITUDE. . .

With these films, minilabs will produce prints ranging from true black & white to sepia or even slightly blue-toned images. I particularly like the faint sepia treatment one gets with Kodak's TCN (a remarkably fine-grained film), but am told the Ilford XP prints better. The new Kodak Select B&W gives true black & white images from the drugstore—in an hour! (If you do your own printing, you can, of course, control the tone of the finished product much better.) Unfortunately, it is available only in 24-exposure 35mm rolls at this writing, not in 120 roll film.

All of these ISO 400 films seem to "see" pretty much the same way. Using the "sunny 16" rule, a shot taken outdoors in bright sunlight ought to be $\frac{1}{400}$ of a second at f16. Since most cameras don't have that

shutter speed, use $^1/_{500}$ of a second at f11. These 400-speed films do have one drawback—it is almost impossible to open the aperture wide enough if you want to blur the background. Even in open shade, you might be shooting at $^1/_{500}$ of a second at f5.6. In a 35mm camera, this still allows for fairly extensive depth of field. An additional complication arises with older classics that do not have very high shutter speeds. That is, if the "sunny 16" rule suggests a reciprocal shutter speed of $^1/_{400}$ of a second at f16, how will you control the light if you are using a folder whose top shutter speed is only $^1/_{200}$ of a second? Of course you can stop down to f22, but what if you want to throw the background out of focus for a portrait? You can't do it! A neutral density filter could help, as could waiting until later in the day and using shady spots for portraits. That's what I mean when I say that a film emulsion helps shape how you see.

Color Slides and Negatives. Modern color films have good color latitude as well as exposure latitude and the color analyzers used in commercial developing and printing today help cure color shifts. Hence, when I need a slower film for a camera, as outlined above, I will use Kodak Gold Max. Shooting color negatives on classic cameras works out fine as long as you shoot for the average overall exposure.

YOU'D BE WELL ADVISED TO BRACKET EXPOSURES WITH YOUR CLASSIC—WHATEVER FILM YOU USE.

If you want to live on the edge, shoot color slide film—available in all sorts of emulsions, including "warm," "soft" and "vivid" color saturations from various manufacturers. Where modern color print films will produce a usable, even pleasant image when exposure is off by a stop or two, slide films are far less tolerant, usually washing out (overexposure) or blocking up (underexposure) if you vary too much from the "right" amount of light. Therefore, exposure for

color slides requires a somewhat different approach. Because slide film has less exposure latitude than negative emulsions do, one should expose for the highlight area(s), and let the shadows darken. Slide film is transparent, and you'll be amazed at how much detail will remain in the shadows. If you really want to learn to read light stick with exactly one slide film for a couple dozen rolls and note your exposure each time you shoot.

As I am partially color-blind—tending to confuse the "charcoal" or muted shades (often calling something green when it is gray, or vice-versa), and seeing some obnoxious shades of purple as blue—I will not attempt to discuss which color films render color "truer" than others. In general, though, I have found that Fuji color films seem to be more contrasty and "punchy" than Kodak films. I have long liked the slides I get with Kodachrome 64 and don't see any reason to stop using it, though I rather like Fuji Velvia, pushed from ISO 50 to ISO 200, on overcast or rainy days.

Bracketing. Unless you chose a sheet film camera where one exposure might cost $1 or $2 in film stock, you'd be well advised to bracket exposures with your classic—whatever film you use. That's easy with scenics, since mountains seldom move. If the scene suggests an exposure of $1/500$ of a second

. . . BRACKET EXPOSURES WITH YOUR CLASSIC— WHATEVER FILM YOU USE.

at f11, shoot that. Then slow the shutter speed to $1/200$ of a second at f11 to retain the same depth of field but give it twice the light. Finally, take another shot at $1/500$ of a second at f16 to give it half the exposure and get even better depth of field. One can also leave the shutter alone and just open and close the aperture. Remember, opening up the lens (or slowing down the shutter) by one stop doubles the light hitting the film; closing down the aperture (or speeding up the shutter

speed) one notch halves the light falling on your film.

The main thing is to be ready when a picture presents itself. This is especially important when shooting photographs of people, sports, kids and pets. Have your shutter set, aperture estimated and the camera wound with its shutter cocked. Some people even more or less prefocus if they think something interesting will happen, as at a sporting event. The old press photographer's mantra "f8 and be there" still holds true. Be there, bracket exposures, and with today's films you'll miss very few shots—even if your classic camera's built-in meter died fifteen years ago!

Film Brands. Kodak, Konica, Fuji, Agfa and Ilford have their loyalists for both color and black & white emulsions. Whether you shoot slides, color or black & white print films, try standardizing your film emulsion. Experiment first to see what brand gives you the kind of colors or grain and black & white tonal balance you prefer, then adopt one or two film speeds to handle your kind of photography—and stick with them. Learning what the film can and cannot do and how it behaves when the exposures are off a little (or a lot) will help you read light better (with that particular emulsion), and rely less on meters. Your photography will take on a more natural ease, and you will be able to think creatively without being bogged down with minutiae. Sure, you might radically underexpose or overexpose some film from time to time, but that just provides a reason to go out tomorrow to look for more images.

WHETHER YOU SHOOT SLIDES, COLOR OR BLACK & WHITE PRINT FILMS, TRY STANDARDIZING YOUR FILM EMULSION.

18.
The Ubiquitous Polaroid

*P*OLAROID CAMERAS CAME ON THE MARKET after World War II and truly revolutionized photography. No longer did you have to wait for a week to see your snapshots. In fact, they promised a picture in a few moments—a terrific selling point, one that remains valid today. More than that, Edwin Land (Polaroid's inventor) wanted desperately to make the whole process of photography totally simple. Unlike the Brownie concept (which depended on learning when there was enough light to capture an image) he wanted every shot to come out. Each successive Polaroid camera introduced more automation into the realm of photography than the last, culminating in the One-Step. Just pop open the film door and pop in a film pack (with fresh battery attached). The camera ejects the dark slide, brings the first film into plane and waits for you to push the button. Then, the electric eye takes care of exposure and the sonar autofocus (and automatic flash) take care of the rest.

EDWIN LAND (POLAROID'S INVENTOR) WANTED DESPERATELY TO MAKE THE WHOLE PROCESS OF PHOTOGRAPHY TOTALLY SIMPLE.

If Land's instant cameras have fallen out of favor it is because the conventional camera industry fought

A totally modern classic, the Polaroid SX-70 Land Camera remains a favorite among art photographers.

back, first with auto-everything point and shoot cameras, then with the totally automated one-hour processing station found in many drugstores and supermarkets. Still, the Polaroid was and remains a marvel—especially in its latest iterations.

There is a Polaroid collecting subgroup, and one cannot talk about "classics" without at least mentioning these cameras. However, except for the earliest models, which were more like classic folders than anything else (and for which the roll film is no longer available), they fall outside the scope of this book because they are far too high-tech. If you want to amass a collection of Polaroid cameras, though, nothing could be easier. They seem to have been sold by the millions and discarded as soon as point and shoot 35mm cameras came along (or the family turned to video cameras). Garage sales are full of them.

I recently bought a pristine Pronto B (with a zone-focus lens that uses the currently available SX-70

This Polaroid J66 might come up for sale at an auction. Before bidding on a camera, though, check to see if film is still available. Polaroid no longer makes film for this camera, for example. (Photo courtesy of David Arndt)

▣ *Polaroid Backs*

A host of Polaroid "backs" exist for both medium format and large format cameras, and one can use them to produce brilliant one-of-a-kind color and black & white images. Professionals often use these as "proofs" to show the client how the product or scene looks, as well as to test their studio lighting setups.

film) and have purchased both SX-70s and Spectra cameras at garage sales for as little as $5—a fraction of their selling prices. If you know your Polaroids, they are worth haggling over. The last Pronto I bought cost $1, the one before that (with the rare ITT electronic flash!) cost me $5. A new Spectra can be had for around $80–90 today, so picking one up in a case with the instruction book for a fraction of the price was a real thrill!

The most revolutionary camera Polaroid ever made, in my opinion, was the SX-70 that folds flat and accordions open to become true single lens reflex with a sharp manual focus lens and automatic exposure. Film is still available for this camera. I also like the equally "techy" Spectra, which uses some of the best film Polaroid ever made.

To play with a Polaroid on the cheap, pick up any one of the myriad Polaroids that take 600 film. This is available in color and black & white, as well as special film designed for use with scanners and copy machines, film one can write on, and film that becomes greeting cards.

As I said, the best Polaroid cameras are far too automated and scientifically advanced to really fit into this book. They are fun, though, and you can get a picture in a minute with some of them. If nothing else, an SX-70, with its ultra-close focusing capability is a wonderful way to document your collection for insurance purposes.

19.

An Easy Entree Into Classics

*E*XCEPT FOR FOLDERS, which I discussed early on, the least expensive way to try classic photography is to find a fixed-lens viewfinder or rangefinder camera. One of the best is the post-World War II Voigtlander Vito B. (There were also folding Vitos, but this one is a simple viewfinder camera, all metal, with no chance of leaking bellows or misaligned lens boards, and a single "normal" lens.) Since the days of the daguerreotype, Voigtlander lenses have been among the world's best, but you may want to try to get one with a Color-Skopar lens for the crispest results.

...THE LEAST EXPENSIVE WAY TO TRY CLASSIC PHOTOGRAPHY IS TO FIND A FIXED-LENS VIEWFINDER OR RANGEFINDER CAMERA.

Other viewfinder cameras (some with rangefinders, too) from Diax, Balda, and Agfa can be found quite reasonably. There are also any number of Yashica, Minolta, Ricoh and Fuji cameras from Japan. Most of them are really good, and some are remarkable bargains. Similar cameras were made in Britain, France and even Italy. One, the Ducati, was made by the same company that makes the powerful motorcycles today. All these typically have a lens of 40mm–50mm focal length (probably f3.5 to f1.7), and come with a leaf shutter speeded to $\frac{1}{250}$ of a second or

The Argus C3 (foreground) and the later C-4 (background) brought the interchangeable-lens 35mm camera to the masses. The famous "brick" can still be bought in working order for as little as $10, as these two examples were.

$1/_{500}$ of a second, tops. The best of these should cost well under $100.

Kodak made a ton of 35mm cameras of this specification that sold for less than the Retinas. For one, there are "Retinettes" that do not fold. There are also a variety of Kodak 35mm cameras that even had rangefinders and can be found in very good shape for $50 or less.

Ciro 35, Graphic 35 and Argus 35s are thick on the ground and can take surprisingly good photos. They

all have rangefinders. A good Argus C3 introduced in 1939 (a camera that looks like a brick with a lens attached) can be found for $5–$10. Getting one with the auxiliary 100mm portrait lens and a 35mm wide-angle lens will up the price; getting one that works perfectly will up the ante further. I picked up a later-model Argus C4 that not only looks nearly new but functions perfectly for $10 at a garage sale.

❦ ROLLEI 35MM

Interestingly, some viewfinder cameras, like the Rollei 35—my current favorite "pocket camera"—will sell for $200, despite having to be focused by guessing the distance. The desirability of the Rollei 35 stems in part from the fact that it was a real camera design landmark. It is tiny, about the size of a pack of ciga-rettes, and thus set the style for all 35mm "pocket" cameras that followed. It is also all metal (or mostly so), and so has a kind of "professional" heft to it despite its diminutive size. The viewfinder has bright lines (easy to use for eyeglass wearers), and it features a 40mm focal length lens that collapses into the body for trans-port and locks out for picture taking. There is no rangefinder, but setting the camera by guess is accu-rate enough, especially since the Rollei has incredibly sharp optics. (Besides, scale focusing with a 35mm camera is not the problem it can be with a larger for-mat instrument.)

THE DESIRABILITY OF THE ROLLEI 35 STEMS IN PART FROM THE FACT THAT IT WAS A REAL CAMERA DESIGN LANDMARK.

The little Rollei can be carried in a shirt pocket. Its tiny electronic flash (powered by a pair of AA cells) and a spare roll of film fit into another pocket, so the whole rig is easy to carry anywhere. The built-in light meter (when it works) is an accurate electronic one that is coupled to the shutter speed and aperture set-tings and can be read by matching the needles. I have

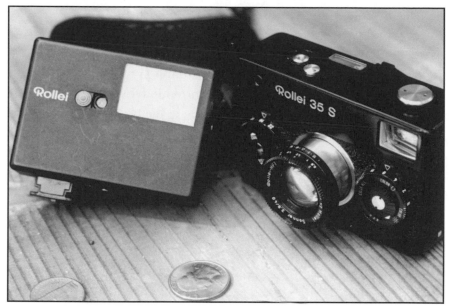

Its tiny size makes this Rollei a take-everywhere camera. The sharp 40mm lens equals the vaunted Leica quality for a fraction of the price.

two of these cameras whose meters are long dead, but find that I really don't need a meter if I think about what film I have in the camera (see pages 158–159).

🍂 OLYMPUS X SERIES

Although they have electronic shutters, I must mention the Olympus X series of cameras. These have a classic "clamshell" design that protects the lens and viewfinder from dirt and pocket dust. They are tiny, and have an amazingly sharp f3.5 lens as well as a built-in light meter. You set the aperture and the camera picks the shutter speed, which is visible with a needle in the viewfinder, thus you do have creative control. If you want to bracket exposures you can "fool" the camera by resetting the film speed (for example, if you are shooting with ISO 200 film, you can set the meter to read for ISO 125 and ISO 400 to bracket your automatic exposures).

THESE HAVE A CLASSIC "CLAMSHELL" DESIGN THAT PROTECTS THE LENS AND VIEWFINDER FROM DIRT AND POCKET DUST.

The XA has a tiny split-image rangefinder, which I never found very easy to use. The XA2 uses zone focus —set the lens to a flower (close), a head, a group or a mountain (distant) and you'll be close enough to perfect focus given the depth of field provided by the 35mm lens. This camera, while a classic in design, was produced at the very end of the classic era and is too electrified for some tastes. Nonetheless, I include it because it is a true landmark, takes superb pictures, and you can still get the button-cell batteries that it needs.

❦ MINOX

Minox made some 35mm cameras that worked in a similar fashion to the Olympus XA camera and had good optics. They also use zone or scale focus, but have a little trapdoor that drops down to expose the lens—sort of like a 1930s era folding 35mm. They are made of plastic composites, however, and are far smaller than the Retina and its competitors, as well as far, far lighter—mere ounces. They can be carried all day in a shirt pocket without anyone noticing they are there. A friend of mine once sold a magazine cover of a grab shot he snapped with a Minox 35mm at a seawall one sunset evening as a sailboat drifted past, heading for the open water. He earned enough money from that one sale to pay for the pocket camera! I sold a picture of a fire that was taken with a modern plastic pocket camera; it was enlarged to run across five columns in my newspaper.

THEY ARE MADE OF PLASTIC COMPOSITES, HOWEVER, AND ARE FAR SMALLER THAN THE RETINA AND ITS COMPETITORS...

If there is a moral here it is to always have a camera within easy reach—and what is easier than a camera that slips into a pocket?

20.
A Final World

*T*HE AIM OF THIS MODEST VOLUME is not to impart any great expertise, and certainly not to dictate what you should be seeking in the way of a classic to use. As I said before, everyone has opinions about what make, format or design is most appealing. That's why they invented both chocolate and vanilla ice cream. Moreover, everyone has had good or bad experiences with one sort of camera or another—and when you buy used equipment you will soon find out that every seller uses a different "grading system," too. (Most are a bit more optimistic than the system a buyer would adopt, of course.)

THERE IS ONE REAL CONSIDERATION IF YOU HAVE NOT YET MADE A COMMITMENT. There is one real consideration if you have not yet made a commitment. That is the fact that the kind of camera you use will, in a way, dictate your view of the world. Put another way—your personal kind of photographic practice will likely determine the sort of camera you eventually find yourself taking off the shelf when you head out.

If you are the contemplative type for whom the perfectly composed and aligned image, carefully printed, is the supreme goal, you will likely drift to either a view camera, with its nearly infinite adjustments. Or

perhaps you will choose a medium format single lens reflex camera with an array of lenses that help you "see" what you envision.

The same might be said of the 35mm SLR, which surely has the most extensive battery of optics available for any camera design. For most photography the 35 mm SLR is more than adequate. I find they are best suited to nature, wildlife or sports photography.

Photojournalists can be well served by the 35mm SLR, too, but if you want to capture people in an intimate way, I still believe the smaller, lighter rangefinder 35mm, equipped with two or three lenses from 20mm–90mm makes the best sense. A lot of very successful practitioners of this kind of work can even get by in most cases with a single 35mm lens. (In fact, the common joke about Leicas is that their owners might as well have welded the 35mm lens onto the body since they never take it off, anyway.)

A LOT OF VERY SUCCESSFUL PRACTITIONERS OF THIS KIND OF WORK CAN EVEN GET BY IN MOST CASES WITH A SINGLE 35MM LENS.

The roll film twin lens reflex falls somewhere between all other camera types. It is sturdy and relatively lightweight, portable and very versatile. The TLR does not seem to intimidate one's targets as much as an eye-level camera might, and it has a relatively large negative, so cropping obviates the need for a telephoto in many instances. The TLR is great for landscapes, kids, pets and—as we have seen—subjects like cars, and motorcycles.

All of these are classic designs, too, and all of these types remain relatively affordable if one wants to experiment.

In writing this book, I aimed to encourage you to get out the old cameras and give them a try. They are fun to use for one thing, and if you become a bit besotted by classic cameras, that's not such a bad thing either. As you shop the Internet, camera stores,

specialty dealers, flea markets and garage sales, you might find yourself acquiring a lot of gear.

When I was gathering hardware for this book, for example, I began buying lots of cameras, just to see how they worked. I could have borrowed many from friends, at least to handle them and take their photos, but I became really intrigued. I know what to expect from a Rollei TLR, a Nikon SLR, or even a Leica, Contax, Nikon or Canon rangefinder system, but I had never used a folder (and still have not used a large-format SLR like the old Graflex). The newer Bronicas or Hasselblads remain a new experience for me, but they are so similar to the TLRs and 35mm SLRs that I know I'd have no trouble learning how to use them effectively. Nor was I personally familiar with the small, pocketable Rollei 35, which is my current pet.

I still am learning and still having a lot of fun—and the hobby has not yet broken the bank. It is easy to buy a decent modern 35mm and a clutch of lenses, a sturdy tripod and a flash unit and discover you have spent the better part of $4,000. For that money you could have a complete (mechanical) SLR outfit (albeit thirty years old), a twin lens reflex taking 6cm x 6cm negatives, a 35mm pocket camera and a folder that gave you 6cm x 9cm negatives, plus filters, lens shades and even electronic flashes for each kind of instrument—and you'd still have enough money left to buy film and take your best girl out for dinner and a movie. Most of all, you'd have a great deal of fun assembling the kits. If a certain style of camera began to exert more pull on you than another, you could also sell the unwanted stuff and lose very little. In some cases, you might even turn a small profit!

YOU'D STILL HAVE ENOUGH MONEY LEFT TO BUY FILM AND TAKE YOUR BEST GIRL OUT FOR DINNER AND A MOVIE.

As I mentioned before, the deliberate nature of classics is such that one must take time, make deci-

sions and concentrate much harder before tripping the shutter than one does with a modern auto-every-thing camera. Thus, one is forced to previsualize images. If you can curtail the "collecting mania" that seems a natural offshoot of the classic camera hobby let me suggest this challenge: Next year, limit yourself to just one kind of camera—a Retina, say, or a Rollei TLR. Limit yourself further to one film emulsion. You won't be able to rely on interchangeable lenses for special effects and will have to crop—or zoom—with your feet, and raise or lower your body to shift camera angles to aid in creativity. I believe, by the end of that year, you'll start seeing more photos, and develop a better eye.

A YEAR WITH A CLASSIC WILL INFUSE YOUR HOBBY WITH NEW SPICE AND MAKE YOU A BETTER PHOTOGRAPHER.

If photography has stopped being fun, and your photos have started having a kind of bland sameness about them, a year with a classic will infuse your hobby with new spice and make you a better photographer. You will learn to work within the limits of the equipment and, if you are sensitive to what's happening in front of the lens, will soon relearn photography—the art of painting with light.

Biographical Information

Author **Michael Levy** has been taking photos since 1946, when, at the age of seven, he was given a simple plastic box camera that used 127 film. He learned the rudiments of composition, film developing, contact printing and enlarging and used his father's Rolleicord and Speed Graphic on occasion while working his way up through a series of Kodak box cameras, culminating with a Kodak Duaflex in 1955 when he was a photographer for his high school paper. A local news photographer gave him a "real" camera, a 4" x 5" Crown Graphic, and also gave him the run of the paper's

Photograph by Cynthia Levy

darkroom. A friend's father also loaned him a Leica IIIf. In college, he began using a Rolleiflex and, in 1965, returned to rangefinder cameras with a Nikon 2S with 35mm and 85mm lenses. That was succeeded by Nikon SLR cameras, and eventually to fully automatic SLRs and point and shoot pocket cameras. Five years ago he returned to "classics" and uses them almost exclusively. A freelance writer, Levy has for years illustrated his own articles.

Contributor **Jonathan P. Blumb**, a Leica user since 1973, has a studio in Lawrence, Kansas, where he prints from vintage negatives, does product and still-life photography for a number of commercial clients (including Nintendo games) and specializes in outdoor and aerial photography. He's currently expanding his portfolio and stock list of hunting and fishing images. Blumb's work has been widely exhibited and has won numerous prizes from (among others) the Outdoor Writers' Association of America. His images are in the permanent collections of several museums, including the Kresge in Grand Rapids, MI, and the Kansas Art Museum in Topeka. He has been widely published in newspapers, magazines and books. Blumb may be contacted at: 835½ Massachusetts St, Lawrence, KS 66044; by phone at (785) 842-7666; fax at (785) 842-7183, or via e-mail at <jblumb@ibm.net>.

Contributor **Nolan Woodbury** calls himself a "semi-pro" who uses classic twin lens reflexes because they work for him. An avid motorcyclist, he has combined both his passion for photography and for motorbikes by contributing to a number of specialized magazines. He is on the staff of *MotoRetro*, an English periodical devoted to high-powered, classic road and racing machines. He can be reached at P.O. Box 1167, Coolidge, AZ 85228.

Additional Resources

❦ Books

Arndt, David Neil. *How to Buy and Sell Used Cameras.* Amherst Media, 2000.

Bower, Brian. *Leica Lens Book.* D&C Publishing, 1998.

———— *Leica M Photography.* D&C Publishing, 1998.

———— *Leica Reflex Photography: New Edition Featuring the Leica R8.* D&C Publishing, 1997.

Comon, Paul. *Pentax Classic Cameras.* Silver Pixel Press, 1999.

Evans, Arthur. *Collector's Guide to Rollei Cameras.* Watson-Guptill, 1986.

Lind, Barbara (ed.), James M. McKeown and Joan C. McKeown. *Lind's List Camera Price Guide and Master Data Catalog 1996–97.* Amphoto, 1997.

Mantale, Ivor. *Collecting and Using Classic Cameras.* Thames & Hudson, 1992.

———— *Collecting and Using Classic SLRs.* Thames & Hudson, 1997.

McBroom, Michael. *McBroom's Camera Bluebook: A Complete Up-to-Date Price and Buyer's Guide for New & Used Cameras, Lenses, and Accessories.* Amherst Media, 1999.

McKeown, James M. and Joan C. McKeown. *Price Guide to Antique and Classic Cameras 1999–2000.* Centennial Photo Service, 2000.

Sartorius, Ghester. *Identifying Leica Cameras: The Complete Pocket Guide to Buying and Selling Leicas Like an Expert.* Amphoto, 1997.

———— *Identifying Leica Lenses: The Complete Pocket Guide to Buying and Selling Leica Lenses Like an Expert.* Amphoto, 1999.

Tomosy, Thomas. *Camera Maintenance & Repair: Book 1.*
Amherst Media, 1997.

———— *Camera Maintenance & Repair: Book II.* Amherst Media,
1998.

———— *Leica Camera Repair Handbook.* Amherst Media, 1999.

———— *Nikon Camera Repair Handbook.* Amherst Media, 2000.

———— *Restoring Classic and Collectible Cameras.* Amherst
Media, 1998.

———— *Restoring the Great Collectible Cameras.* Amherst Media,
1999.

Williams, Peter B. *Medium Format Cameras: User's Guide to
Buying and Shooting.* Amherst Media, 2000.

❧ PERIODICALS

Camera Shopper
This monthly periodical features articles on classic cameras and
classified ads for cameras and photographic equipment.

Shutterbug
This monthly periodical features articles on photography in general and is well known for its hundreds of advertisements from vendors selling used and new photographic equipment.

The Trader's Edge
This publication tracks about 15,000 used camera and accessory
prices by region.

❧ PARTS, TOOLS, REPAIRS AND RESTORATION
The information listed in this section is provided as a resource for
the reader. No endorsement of these companies' or individuals'
products or work is stated or implied.

Camera Bellows, Ltd. (stock and custom bellows)
Runcorn Works
2 Runcorn Rd.
Birmingham 12, England

Camline Industries (photographic test equipment)
PO Box 406
Running Springs, CA 92382 USA

Edmund Scientific (tools, optics)
101 E. Gloucester Pike
Barrington, NJ 08007 USA

The Focal Point (lens recoating)
1027 South Border Rd. #E-1
Louisville, CO 80027 USA

Golden Touch (screw-mount Leica parts, service)
118 Purgatory Rd.
Campbell Hall, NY 10916 USA

Photo Parts Source (parts, service manuals)
29659 US Hwy 40W
Golden, CO 80401 USA

Western Bellows Co. (custom bellows)
9340 7th St., suite G
Rancho Cucamonga, CA 91730-5664 USA

❦ PHOTOGRAPHIC EQUIPMENT MANUFACTURERS

Web and internet information was correct at the time of publication. If a site has since moved, it can usually be tracked down using one of the many Internet search engines. Keep in mind that these addresses are for modern manufacturers who may or may not be able to directly offer information on classic models. Nonetheless, they may be of use in initiating research on classics.

Agfa
 <http://www.agfanet.com>
Ansco Photo Optical Co.
 1801 Touhy Ave.
 Elk Grove Village, IL 60006

Beseler

<http://www.beseler-photo.com>

Bogen Photo Marketing (Metz, Gitzo, Gossen)

565 E. Crescent Ave.

PO Box 506

Ramsey, NJ 07446

<http://www.bogenphoto.com>

Bronica

<http://www.tamron.com>

Canon USA

One Canon Plaza

Lake Success, NY 11042

<http://www.usa.canon.com>

Contax

<http://www.contaxcameras.com>

Eastman Kodak Co. (Kodak, Wratten)

800 Lee Rd.

Rochester, NY 14650

<http://www.kodak.com>

Fuji Photo Film USA (Fuji, Fujica, Fujinon)

555 Taxter Rd.

Elmsford, NY 10523

<http://www.fujifilm.com>

Hasselblad, Inc. (Hasselblad, Softar)

10 Madison Rd.

Fairfield, NJ 07006

<http://www.hasselbladusa.com>

Ilford Photo Corp.

<http://www.ilford.com>

Konica USA, Inc.

440 Sylvan Ave.

Englewood Cliffs, NJ 07632

<http://www.konica.com>

Kyocera International, Inc. (Kyocera, Contax, Zeiss, Yashica)

100 Randolph Rd.

Somerset, NJ 08875

Leica Camera, Inc.
 156 Ludlow Ave.
 North Vale, NJ 07647
 <http://www.leica-camera.com>

Mamiya America Corp.
 <http://www.mamiya.com>

Minolta Corp. (Minolta, Cokin)
 101 Williams Dr.
 Ramsey, NJ 07446
 <http://www.minoltausa.com>

Minox
 <http://www.minox.com>

Nikon, Inc.
 1300 Walt Whitman Rd.
 Melville, NY 11747-3064
 <http://www.nikonusa.com>

Olympus Corp. (Olympus, Zuiko)
 2 Corporate Center Dr.
 Melville, NY 11747-3157
 <http://www.olympus.com>

Pentax Corp.
 35 Inverness Dr. E.
 Englewood, CO 80112
 <http://www.pentax.com>

Polaroid Co.
 575 Technology Square
 Cambridge, MA 02139
 <http://www.polaroid.com>

Ricoh Corporation
 475 Lilliard Dr. #101
 Sparks, NV 89434
 <http://www.ricohcpg.com>

Rollei Fototechnic
 <http://www.rolleifoto.com>

Schneider Optics
 <http://www.schneideropticst.com>

Sigma Co. of America
 15 Fleetwood Court
 Ronkonkoma, NY 11779
 <http://www.sigmaphoto.com>
Tiffen
 <http://www.tiffen.com>
Yashica
 <http://www.yashica.com>

❦ INTERNET RESOURCES
<www.smu.edu/~monagha/mf/index>
 Good source of information for those interested in
 medium format photography.
<www.graflex.org>
 A site for all things Graflex, and for Speed Graphic
 cameras.
<www.merrillphoto.com/index.html>
 Website run by a professional photographer with a
 passion for "junk store" cameras. Features inspir-
 ing images and information on loading primitive
 box cameras.
**<www.people.we.mediaone.net/wymanburke/TheRol
leiPage.html>**
 Features links for both TLR and 35mm Rolleis.
<www.geocities.com/Vienna/7008>
 Loads of information on the ever-popular Argus
 35mm cameras.
<www.rwhirled.com/landlist/landhome.htm>
 Includes a list of available Polaroid films and what
 cameras use them.

Index

Amherst Media™
Books For Classic Camera Collectors and Users

How to Buy and Sell Used Cameras

David Neil Arndt

Learn the skills you need to evaluate the cosmetic and mechanical condition of used cameras, and buy or sell them for the best price possible. Also learn the best places to buy/sell and how to find the equipment you want. $19.95 list, 8½x11, 112p, b&w, 60 photos, order no. 1703.

Medium Format Cameras: User's Guide to Buying and Shooting

Peter Williams

An in-depth introduction to medium format cameras and the photographic possibilities they offer. This book is geared toward intermediate to professional photographers who feel limited by the 35mm format. $19.95 list, 8½x11, 112p, 50 photos, order no. 1705.

McBroom's Camera Bluebook, *6th Edition*

Mike McBroom

Comprehensive and fully illustrated, with price information on: 35mm, digital, APS, underwater, medium & large format cameras, exposure meters, strobes and accessories. Pricing info based on equipment condition. A must for any camera buyer, dealer, or collector! $29.95 list, 8½x11, 336p, 275+ photos, order no. 1553.

Amherst Media™

Camera Repair Books by Thomas Tomosy

Other Books from
Amherst Media™

Build Your Own Home Darkroom

Lista Duren & Will McDonald

This classic book teaches you how to build a high quality, inexpensive darkroom in your basement, spare room, or almost anywhere. Includes valuable information on: darkroom design, woodworking, tools, and more! $17.95 list, 8½x11, 160p, 50 photos, many illustrations, order no. 1092.

Creating World-Class Photography

Ernst Wildi

Learn how any photographer can create technically flawless photos. Features techniques for eliminating technical flaws in all types of photos—from portraits to landscapes. Includes the Zone System, digital imaging, and much more. $29.95 list, 8½x11, 128p, 120 color photos, index, order no. 1718.

Into Your Darkroom Step-by-Step

Dennis P. Curtin

This is the ideal beginning darkroom guide. Easy to follow and fully illustrated each step of the way. Includes information on: the equipment you'll need, set-up, making proof sheets and much more! $17.95 list, 8½x11, 90p, hundreds of photos, order no. 1093.

Black & White Photography for 35mm

Richard Mizdal

A guide to shooting and darkroom techniques! Perfect for beginning or intermediate photo-graphers who want to improve their skills. Features helpful illustrations and exercises to make every concept clear and easy to follow. $29.95 list, 8½x11, 128p, 100+ b&w photos, order no. 1670.

Big Bucks Selling Your Photography, 2nd Edition

Cliff Hollenbeck

A completly updated photo business package. Includes starting up, getting pricing, creating successful portfolios and using the internet as a tool! Features setting financial, marketing and creative goals. Organize your business planning, bookkeeping, and taxes. $17.95 list, 8½, 128p, 30 photos, b&w, order no. 1177.

Special Effects Photography Handbook

Elinor Stecker-Orel

Create magic on film with special effects! Little or no additional equipment required, use things you probably have around the house. Step-by-step instructions guide you through each effect. $29.95 list, 8½x11, 112p, 80+ color and b&w photos, index, glossary, order no. 1614.

Macro and Close-up Photography Handbook

Stan Sholik

Get close and capture breathtaking images of small subjects – flowers, stamps, jewelry, insects, etc. Designed with the 35mm shooter in mind, this is a comprehensive manual full of step-by-step techniques. $29.95 list, 8½x11, 120p, 80 photos, order no. 1686.

Outdoor and Location Portrait Photography

Jeff Smith

Step-by-step discussions and helpful illustrations teach you the techniques you need to shoot outdoor portraits like a pro! $29.95 list, 8½x11, 128p, 60+ b&w and color photos, index, order no. 1632.

Outdoor and Survival Skills for Nature Photographers

Ralph LaPlant and Amy Sharpe

Learn all the skills you need to have a safe and productive shoot—from selecting equipment, to finding subjects, to dealing with injuries. $17.95 list, 8½x11, 80p, order no. 1678.

The Art of Infrared Photography, *4th Edition*

Joe Paduano

Practical guide to the art of infrared photography. Includes: anticipating effects, color infrared, digital infrared, using filters, focusing, developing, printing, hand-coloring, tonin... 112p, 70 phot...